BUILDINGS IN
WATERCOLOUR

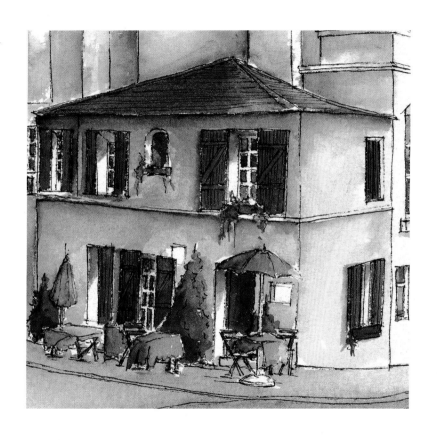

BUILDINGS IN WATERCOLOUR

Richard S. Taylor

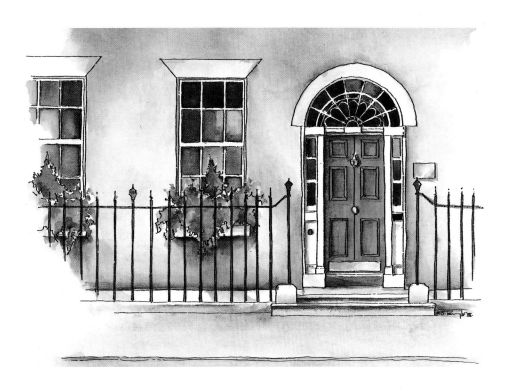

B. T. Batsford Ltd, London

First published 1989

ISBN 0 7134 6178 0

Phototypeset by Keyspools Ltd
Printed in Hong Kong
for the publishers, B.T. Batsford Ltd,
4 Fitzhardinge Street,
London, W1H 0AH

CONTENTS

INTRODUCTION

Much of my youth was spent travelling—not primarily as an artist or illustrator, but as a young man with a fascination for different places, cultures, and experiences. The grandeur of Brussels and Paris, and the 'cultured' atmosphere of the stone buildings around the Place Vendôme, impressed me in my more formative days. The images of the old, rickety stone buildings of southern Europe, stacked up on hillside terraces, with their red roof tiles glowing in the late afternoon sun, made a lasting impression also. The highly-decorative gabled buildings that line the canals of old Amsterdam, the heady Alpine huts, and the timber buildings of the dusty Western American states all held a fascination for me that demanded fulfilment and further exploration. And so, as the exploration followed, I developed a lasting interest in architecture and began to turn more to drawing, sketching, and generally recording buildings on my travels.

It was, however, a trip to the Shetland Islands that cemented my curiosity for drawing and painting buildings—the natural patterns of the fragile stone croft walls, the rigid structures of the ashlar block Edwardian town buildings, the harbour-side cottages, and the lighthouses all formed a microcosm of architectural illustration subjects—everything I could have asked for all within a few miles' radius. The fascination turned into near obsession, and my work as an artist/illustrator has since been devoted to the recording of buildings, structures, and architecture in all shapes, forms, and sizes.

My first suggestion to anyone embarking on this voyage of discovery into drawing, sketching and painting buildings is simply to look, everywhere that you go. Look upwards, underneath beams and for unusual roofs and chimney pots. Look sideways along small alleyways—clinging ivy, unusual window frames, peculiar doorways or entrances may all lurk unannounced along a winding side street. Look downwards for the worn stone steps, for the brick nogging where old wattle and daub has been replaced at the base of a wall. Everywhere you look you will see architectural features that may command your attention, or that can form the basis for an interesting and unusual painting. Do try to seek out the unusual—the rewards are generally much greater.

My next suggestion is to get to know your buildings. Throughout this book I have explored the history and development of certain types of building. This is, I believe, important if the buildings that you are sitting in front of are to appear to you as any more than a construction of brick and wood. If they can come to life through their history, then the more absorbing the act of recording them will become. The roads of towns, villages, and cities throughout the world are lined with history—the building styles reflect the times of their origins and are worthy of some of our time, and possibly worthy of a little reverence also.

This leads on to the next consideration—the ethics of working on-site in full public view. As soon as you find what you consider to be a quiet place in a side-road on a Sunday afternoon, you

immediately become a public spectacle. People will want to stop and look over your shoulder—and why, indeed, shouldn't they? They will often want to discuss your work or pass judgement. This is simply one of the many hazards that you will encounter in the great out-doors; tolerance and confidence will help you there! There are many others with a lack of respect for the street artist— notably pigeons in town squares—but these can be avoided by careful choice of site. The next two chapters will deal specifically with equipment and setting-up to sketch and paint. All that really needs to be said at this point is that an obvious level of consideration must be given to those who will also want to use the areas that you are occupying.

Sundays are the most popular days for people to go out painting—the streets are generally less congested and transport is considerably more scarce. Since this is also the most popular church-going day, the church wall may not be the best place to sit and lay out your paints—simply, it could cause offence. Whilst you are at liberty in most countries to sit on a verge and paint an attractive house, always remember that it will often be someone's home. They will probably be flattered by your interest (most people are very proud of their homes); but, equally, you could be the last in a long line of artists to have disturbed their Sunday lunch by peering through their front windows. Again, consideration is the answer.

As you spend more time sketching and painting out of doors, then the more you will gain from your successes, mistakes, and experiences. With this, your own individual style will develop; this will involve techniques, choices of equipment, and types of buildings that you prefer to work on. It must also be said here that not all of my illustrations/paintings were completed on-site. Many started as sketches and were completed at home, in the safe confines of my studio, where circumstances dictated. (There is nothing at all wrong with completing a sketch and painting this at home on the living-room floor, provided you have enough information to refer to.) Others were allowed the luxury of a whole day's painting, and a couple were painted quickly when time or the elements started to force my hand.

Finally, you *can* learn to draw and paint. I know this as I have taught many people, young and old, on an assortment of courses. This book is intended as an instructional guide to be used on-site, at home on the kitchen table, or wherever you choose to paint. Use it to get you started; pack it in your bag before you go out on an expedition; keep it on your book shelf for reference, or simply read it and enjoy it.

— 1 —

EQUIPMENT

After a good many years as a specialist illustrator, having amassed much information on the equipment that I use, I still occasionally find it a little bewildering to enter even the smallest of art shops. Shelves are stacked with a vast array of watercolour pads, loose leaf packs, and single sheets of paper—all of different weights, sizes, textures, and even colours. Then there are the pan paints, tube paints, loose paints, box paints—all different brand names, and all different prices! It is probably true to say that in the case of art materials the most expensive are likely to be of the highest quality, but this does not make them the most suitable for your personal tastes and requirements; it is certainly my experience that the middle price-range of equipment is more than adequate for the beginner and serious student alike.

This, however, is the type of equipment that I have tried over the years and now trust and recommend.

PAPER

As I have already mentioned, there is a vast amount of watercolour papers on the market, including watercolour boards, so some advice on what to look for is appropriate here. If you are going out on painting expeditions and intend to spend much of your time painting on-site, then I strongly recommend a ring-bound pad with a hard-card back. The fold-over types will contain paper of an equal quality and suitability (as will the loose leaf pack), but they are not so practical on a draughty street corner. The ring-bound will allow you to keep an autographic record of the places that you visit and paint at, and prevents your paper from flying off down the road in the wake of a passing motorist, or being lifted on a gentle summer's breeze, only to find the one puddle in the entire village in which to come to rest. Believe me, it happens.

But there are still other complications. What texture and weight paper? Watercolour paper is classified by its weight e.g. 90 lb, 180 lb (200 gms, 400 gms) and its texture (smooth, rag or rough). I tend to use the middle weight papers in the region of 120–200 lb (255–425 gms), as these can be considerably wetted without crinkling or contracting too much. The thinner or less weighty paper may end up like a piece of corrugated cardboard if soaked and dried too quickly in the sun.

I also choose a reasonably smooth-textured paper for drawing purposes. Whilst the rougher papers can provide some exciting textures with the paint runs and blotting techniques, they are not very suitable for use with a pen, since the highly-textured paper will interrupt the smooth flow of the ink, forming a broken line and a scratchy surface. This can also block the nib of the pen, aggravating the problem even more. Perfectly smooth paper is not necessary—simply a paper which is not too rough.

Lastly, on the subject of paper, I never recommend a tinted paper. You can always add a certain tint if you require it, but you cannot remove it from the paper if it looks inappropriate.

PAINTS

Paints are probably the next most important consideration. Watercolour paints generally come in pans or in tubes. The tubes can obviously be purchased separately (as can the pans), but the pans are generally sold in tins, plastic boxes, or presentation sets, all made by a vast array of manufacturers, all with equally-appealing packaging. This is where the level of choice does become bewildering. Personally, I prefer to use pan paints, as they can be kept together in a small box (even pocket-sized) and are easily replaced. The tubes are more bulky and are not quite so functional for on-site working, being easily squashable.

Several 'starter' boxes or tins are available from art shops and contain about six to eight replaceable pans of paint set into one side, with the lid serving as a palette on the other side when opened. I recommend these thoroughly. The more paints you have to choose from, then the more difficult your choice becomes. Also, if you have too many established colours and tones in the form of paints, the temptation is often to use these in the earlier stages of learning rather than mixing. It is unlikely that the established colours will be exactly the ones that you want. If you mix your own, the chances of accuracy are improved considerably, giving you, the painter, control over your own painting.

The colours that I personally choose to work with are: Yellow Ochre, Burnt Umber (brown), Raw Sienna (reddish brown), Prussian Blue, Olive Green, Lamp Black, Winsor Red, and Brilliant Yellow. Apart from the artificial Winsor Red and Brilliant Yellow, my palette consists of natural earthy colours to prevent the buildings I paint looking as if they are lit with neon. Every picture, diagram and illustration in this book was painted with those eight colours only. As I have already mentioned, the more limited the palette, the easier the choice becomes.

A few last words on choice of paint sets. Do take a set out of its wrapping, open it up, and hold it before you buy. Test it for balance—does it feel right for you? After all, you will be spending much time holding it when you are painting on-site. This is one occasion when the decision is totally yours. Also, it is probably best to go for a well-known brand name when buying sets of watercolour paints. These will cost a little more, but it is money well spent. Less-expensive sets will be lacking somewhere, and this will probably be in the quality of the pan paints. Gritty paints are no fun to work with at all.

BRUSHES

Two distinct types of brushes are available for watercolour painting, and both are equally capable of doing the same job, if required. They are nylon and sable. The sable brushes are the best of the two as they can hold water well, yet still maintain a very fine point; they are, however, very expensive. The nylon brushes are perfectly acceptable as a less-expensive substitute, but do not have quite the same feel. I use six brushes in total: sizes Nos 1, 2, 4, 6, 8 and 12. These cover every eventuality, ranging from the large wash capability of the No. 12, through to the fine line detail of the No. 1.

PENS

There are, at present, many fibre-tip pens on the market which are perfectly suitable for drawing with where no colour wash is to be involved, as they bleed when wet, leaving a purplish stain around the line. (This is sometimes quite attractive for monochrome work, but is totally inappropriate for watercolour work.) The only type of pen that can be used is the Indian ink pen. Again, there are many varieties and many trade names to be found in shops. The only priorities should be that they feel right for you when you hold

them, and that you can buy replacement nibs for them when you drop them (and it is very much a case of 'when', not 'if'!).

Most ink drawing pens nowadays are cartridge pens with detachable/interchangeable nibs. I personally find a 0.25 nib serves as a multi-purpose instrument: it is thin enough to allow bricks to be sketched in and picked out convincingly, yet broad enough to add some weight to the shaded side of an oak tree or market stall. One tip worth noting here: always remove the nibs before you go on an expedition, and wash them through with very hot water. This loosens any dried ink and prevents compound blockages occurring while you are on-site. Also, take this opportunity to fill up the cartridge with ink!

FURTHER EQUIPMENT

A few other peripheral items also warrant a mention. A plastic water container is vital, preferably with a screw top so that you can easily move on to another site without worrying about water leaking into your bag. A kitchen roll of paper towels is also invaluable. Apart from being useful for blotting parts of your picture, it also serves for cleaning and wiping brushes.

Finally, you will need a bag in which to carry these items. A canvas shoulder bag will be ideal. (Those that can be bought from Army Surplus stores are well suited as they often have additional pockets.) A shoulder bag is particularly useful as it will give you a free hand with which to carry the folding canvas chair, should you choose to use one. Some people prefer to rely on steps, bollards, and public benches to sit on, but they are not always available just when you need them.

— 2 —

MAKING A START

Having made your choice of equipment, the next stage is to make your choice of building. Several factors should influence this decision. Obviously, whichever building you choose will have a strong personal appeal, either for its unusual colouring, the pure symmetry of its windows, its catslide thatch roof, etc., etc. But before you settle down to paint and establish base camp for the next hour or so, do give serious consideration to the following.

First, are there any major obstacles (generally in the form of large buildings or massive trees) that will obstruct the natural light as the day progresses? Once you become involved with a painting, the hours will fly by rapidly, and before you are really aware of the changes taking place, the entire tonal values of your subject will have changed as the sun moves behind the church tower that you hadn't really noticed before. Of course, the light will always change as you paint, but not too seriously if you choose the best spot. Also, don't be fooled by the weather. An overcast, cloudy day can easily break and shatter your vision with shafts of blinding sunlight. So always work out where the position of the sun is most likely to be, should that break in the cloud occur.

The next potential obstacles for you to consider are the human ones. If you are setting up to paint in a commercial environment, is it likely that delivery lorries will be parking directly in front of your building? In a town or city centre, are you likely to be trying to see your subject through a constantly-changing row of taxis? Or are you likely to find that you are having to peer through a newly-formed bus queue to complete your picture? In other words, simply take note of your full surroundings and not just your subject, as an empty street can rapidly fill with an endless supply of obstacles, should you have chosen a bad spot.

Your own personal comfort is also a matter for serious consideration. As was mentioned in the previous chapter, whilst there are many different types of collapsible easels, donkeys, and drawing boards on the market that may suit individual tastes, my own personal preference (and my personal recommendation) is a folding canvas chair to sit on and a strong card-backed ring-bound watercolour pad to rest on your knees. I have, through past experience as both an artist and a teacher, found anything else simply too cumbersome to take on a painting expedition where several changes of site are involved. The rigid supports of easels can also inhibit the freedom of movement required to practise the 'wetting and blotting' techniques and the direction of the 'water-colour run' that will be discussed as the book progresses.

The last real stage of preparation is to make sure that all your equipment is easily available to you and positioned so that your water-holder, kitchen roll, and brushes are all within arm's reach and can be used with the minimum of movement. The message here really is very simple: the less equipment you take with you, the easier the tasks of setting up and moving on become.

So, having established a simple working base that will suit your purpose for an hour or so, the next stage is the basic sketch.

The arguments rage amongst the purists in art establishments throughout the world regarding the combination of the drawn line and the watercolour technique. Personally, I have no time for the purists whose art belongs in dusty vaults and inaccessible collections. The purity of the paint brush as the only tool in watercolour painting may have some little merit in recording the atmosphere of a Provençal landscape or the colours of a Tuscan vineyard, but for the solid geometric structure of buildings anywhere in the world I strongly recommend the use of ink pens for sketching the main structures. Apart from visually holding the building together and allowing the artist with experience to enhance, highlight, and draw attention to specific features, more important than any other consideration is the fact that it allows the beginner to establish a framework and simple structure to work within, and facilitates the growth of confidence. As it is to this end that this book is chiefly dedicated, it is with the basic pen sketch that I will start.

FIGURE 1

With a little modification here and there, virtually every building can be drawn with a set of basic box shapes. (This method of drawing also makes the concept of perspective easier to deal with.) For this reason I have chosen for an example of the stage-by-stage development of the sketching technique a solid red-brick Georgian building in Colchester, Essex (Figure 1). Whilst this is a classical case of the once-total symmetry being lost by the addition of assorted wings, the geometrical structure of this town building makes it particularly easy to draw with just a few lines.

1

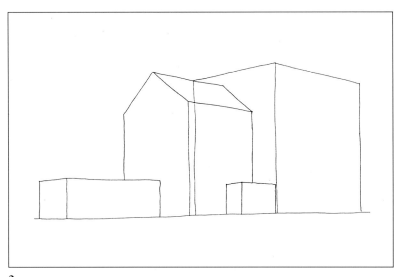

2

FIGURE 2

If you can alter your perception and 'see' buildings as their component boxes, then the drawing of them will become considerably easier. Here in the first stage of the sketch a start is made by drawing the four component boxes within which, or around which, all the features and architectural bits and pieces will fit.

When drawing single or solitary buildings you should find very few perspective problems (these occur chiefly within terraces and will be examined in following chapters). The main perspective here will be along the lines of the roof, in this diagram represented by the top line of the box, as the ground lines are obscured by a wall running the length of the house. As the majority of buildings that you draw will be seen from the ground, the main perspective lines will nearly always run along the lines of the roof.

The concept of perspective is based upon the optical illusion that suggests that all parallel lines converge at a point on the visual horizon. However, since most of the buildings that you will wish to paint will be in built-up areas, or will be surrounded by assorted visual obstructions, it is extremely unlikely that you will ever be able to see a horizon line when you start to sketch. For that very reason, I will not go into the technicalities of perspective here, but will suggest a few quick ways in which you can become accustomed to sketching buildings without going into formal perspective exercises; enjoyment is, after all, a priority.

Being realistic, we must admit that there is really nothing worse than incorrect perspective. The whole building can be made to look highly unstable by a few incorrect lines. It is equally easy, however, to keep your buildings looking upright: simply make sure that all your vertical lines remain vertical! This is, I believe, the key to successful perspective when starting to sketch. One useful hint is to roll your pen or pencil vertically across your picture, stopping every time you come to an upright line, and checking that it is, in fact, upright, and that it is also parallel to all the other vertical lines in the building(s).

Having satisfied yourself that all upright lines stand up straight, it is time to move on to the converging lines. The angles of converging lines on a single building will be slight—the taller the building, the sharper the angle, but only six- to eight-storey buildings should give any real cause for concern.

When you are drawing a building with the corner facing you, as in these diagrams, the angle of convergence of your top lines for the front and side of the building will be similar, though probably not exactly the same; that is for you to judge—a skill that you will rapidly master as you sketch more on-site. You will soon develop an eye for angles and perspective, and, as you gain confidence in your own skill and judgement, you will probably find the more extreme or problem buildings all the more appealing for the challenge that they offer.

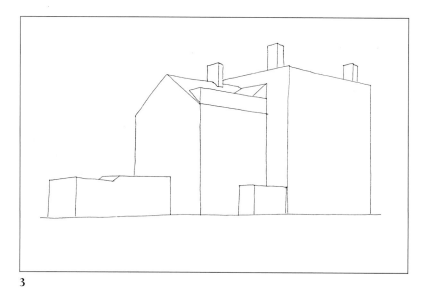

3

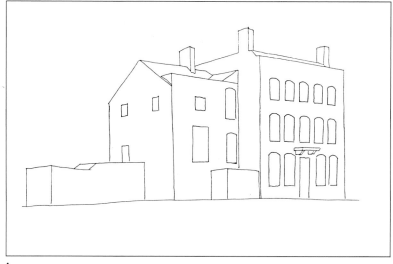

4

F I G U R E 3

F I G U R E 4

Having established the basic box shape, you will be in a much better position to add some of the major peripheral items with greater accuracy and confidence.

Chimney pots are important and are worthy of some consideration here. The straightness and vertical lines of the stacks are vital and can now easily be cross-checked against the upright lines of the main building. The angles of the top lines will be slightly sharper than those of the roof lines because they are that much higher, increasing the level of perspective.

The parapet could also be added now, as the angle of convergence would be clear, i.e. the bottom line would, in fact, be the bottom line of the roof, and its top lines would sit comfortably between the top and bottom roof lines. Once again, you will soon develop an eye for middle sections between converging perspective lines.

This very principle applies to the next stage of drawing in the basic window shapes. Having established the top line of convergence on the roof, and the bottom line along the length of the wall, it is now considerably easier to draw in the windows within the correct perspective framework. Every window of each horizontal row will appear to become respectively smaller as you look along the front of the house. The rules of perspective dictate that these will all fit into a converging pattern.

As the top and bottom lines of the building are already established, the easiest way to begin to draw in the windows is to find the angle of the centre of the three rows, which will be virtually straight across the middle of the front. Having established this central row of windows, you can be sure that the upper row will follow the top line of the roof and the top line of the middle row of windows, making each window progressively smaller. This is

the same with the bottom row, only the top line of the windows will follow the bottom line of the middle row, and the bottom line will follow the line of the wall. When completed, this will result in a solid-looking structure with everything seemingly in its correct place. The last stage now is to finish the sketch by putting in some final details.

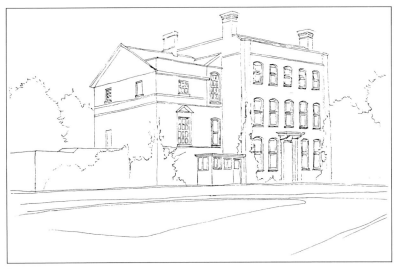

5

Ledges, ornamental decorations, creeping ivy, etc. are all now to be included in the sketch (as well as any important foliage that surrounds the building). This is the point at which it is important to consider the difference between a sketch and a drawing. A drawing is, generally, a finished piece of work in its own right, with much detail and a range of tones. A sketch should be only a few quick (although accurate) lines, which should form the framework within which you are to paint. So don't overdo the sketch. More detail may be drawn onto the picture at a later stage when the paint has dried, should you wish to pick out a few bricks for highlighting or some decorative coursing around a chimney stack. To overwork your sketch could result in you merely tinting a drawing as opposed to using watercolour paint to its fullest potential. So, having completed the sketch, it's now time to move on to the paint palette.

Having positioned yourself comfortably with paints at the ready, and thrown inhibitions and caution to the wind, you can get started. The very first step is to paint the sky. The tone/colour of the sky will ultimately affect the tone of your whole picture, being the source of all the natural light by which you see your subject and its surroundings. So, with a No. 12 brush, paint clean water onto the sky area, soaking the paper thoroughly, and turn your picture upside down with the water running towards you. This prevents water running into the building sections. It is not vital that the buildings are kept dry, but it will prevent the sky colours running too much across areas that you do not want painted. Now mix the sky colour in your palette.

F I G U R E 6

The sky colour that I used here is Prussian Blue, mixed with a very small amount of Burnt Umber to take the edge off the glare and the brightness. With the same No. 12 brush, run a line of paint along the line of the roof, and leave it to bleed as it mixes with the water. This is where you can take control over the sky and twist the paper so that the watercolour paint, as it now is, will run to your requirements, being directed to the left or right as you move the

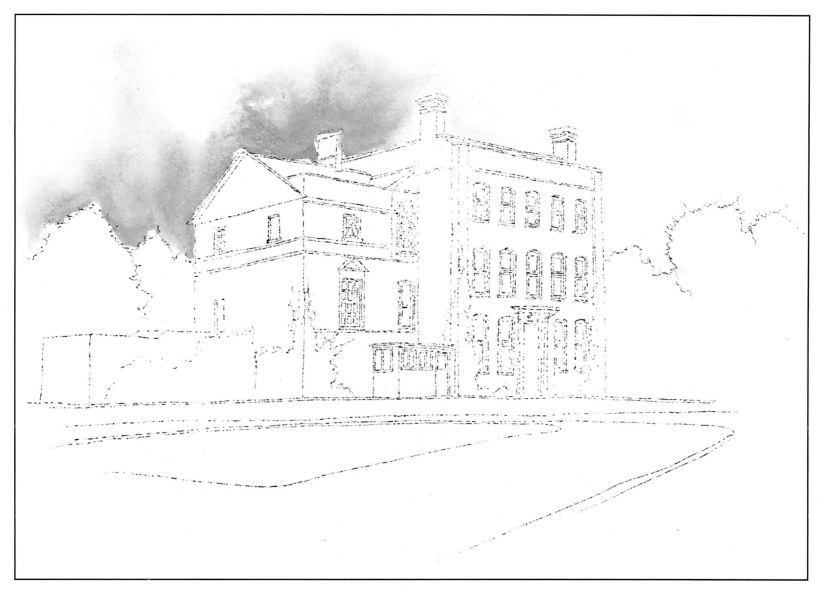

paper. Once the surface water has dried, but the paper is still damp, cloud area can easily be created by simply blotting out the required area with a piece of clean kitchen roll. This technique has been used to create the sky in this sequence.

A word of warning at this point. Those students who have attended winter term evening classes will presumably be familiar with the washing and blotting technique, and will doubtless have practised this in the class setting. The problems arise when you transfer this technique to an outdoor setting, where the water dries considerably more quickly in the wind and sun, leaving you less time to decide where to blot. It will not dry instantly, but will definitely need speedier reactions than would be required indoors.

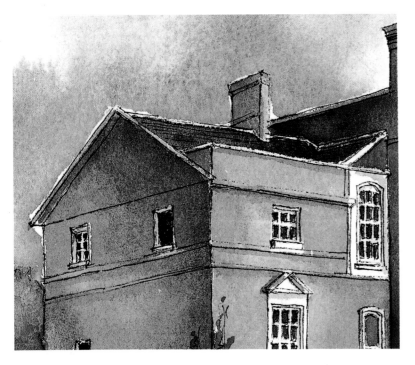

The next stage is to fill in all the rest of the sketch and to establish a basic colour scheme. It is not vital at this stage to consider tones and the forming of a three-dimensional effect by the use of these— this will come later; at the moment it is simply a case of filling-in and of establishing a base to paint onto.

To create the required tones for the building, mix the sky mixture that remains on the palette with a little Raw Sienna, and water it down. This is a standard procedure. Never clean the palette, so the colours that you mix will all then maintain the same basic tonal values. You will often need browns in your sky, and blues in your brickwork, so if you keep the palette going, the tones will mix themselves.

Now mix the roof by adding more Burnt Sienna to the mixture, and the foliage by mixing Olive Green with a little of the roof tone, with the addition of a little purple (Winsor Red and Prussian Blue) for effect. Paint all of these sections onto dry paper, with no runs or bleeds, with a No. 8 brush.

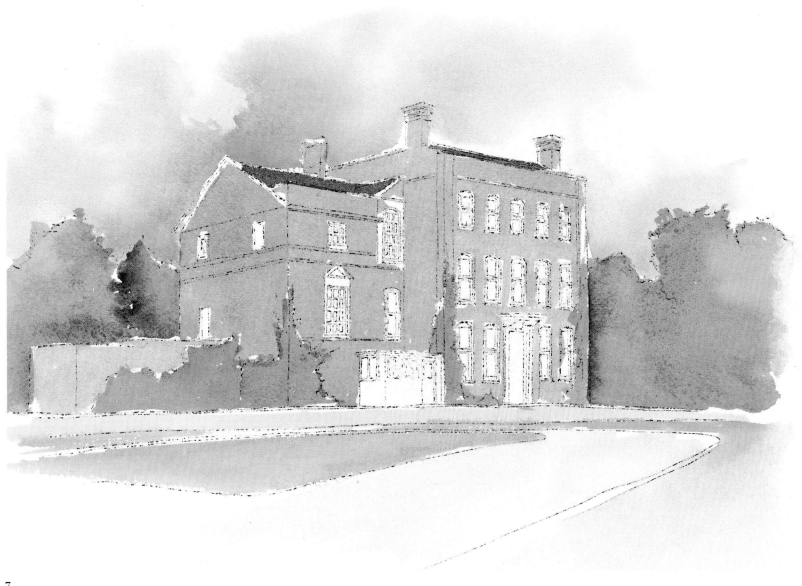

7

FIGURE 8

While the paint is drying (and this won't take long at all when working outdoors) mix a little Lamp Black with the by-now slightly dirty water in your water-holder, and, with a No. 1 brush, paint in the windows.

All colours will dry to a slightly lighter tone than the one that you mixed and painted the paper with. This will also be the case with the windows, and the black will soon be absorbed into the paper, drying to a light grey. A vital point to consider here is that you can always make tones darker by the addition of darker paints, but you will not be able to make a section lighter once the paint has dried into the paper. So don't worry if your painting looks too pale with the first coat—this will be developed in the next stage.

The penultimate stage in the development of your picture is the introduction of shadows and shading. As the picture now has a solid base of colour to work onto, this stage need not be too intimidating as there is no longer any white paper to be covered.

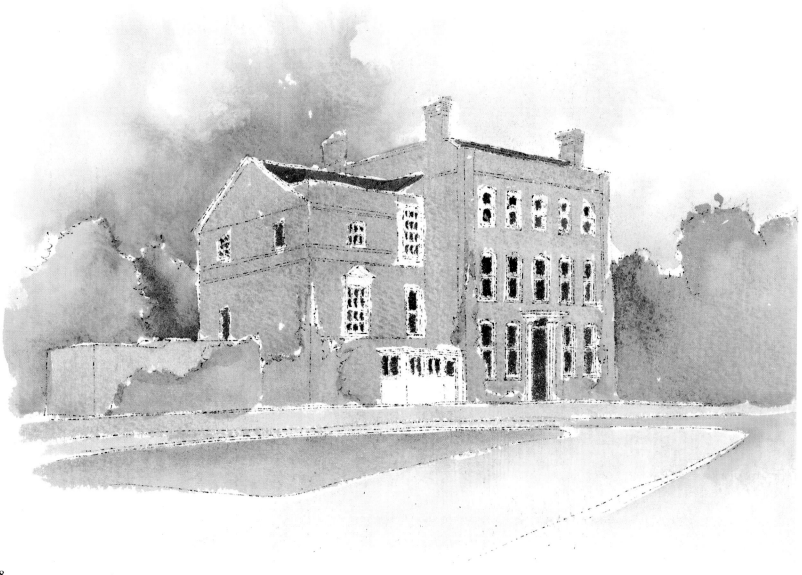

8

FIGURE 9

First, it is vital to establish the major shaded areas. In this particular picture the sun was shining onto the front of the building, leaving some very solid shading on the sides. Darken the brick colour by increasing the amount of Burnt Umber mixed with the Raw Sienna (my basic brick colour) and finally add a little Prussian Blue. Then, with a No. 6 brush, run the paint along the top edge of the side areas and pull it downwards.

To create a texture and to suggest a more natural form of irregular shading, certain areas can be blotted with a piece of kitchen roll. Here you will have a lot more scope for creative blotting, as the tones underneath will show through as you blot, and you can add and blot paint until you are happy with the effect.

Do pay special attention at this point to the sides of chimney pots. Also, look for shadows and shading under ornamental ledges, eaves, window ledges, window frames, etc. It is these details that can really add life to your picture. For these sections a No. 1 brush is generally required. Again using the Prussian Blue, Burnt Umber, and Raw Sienna mix, paint a straight line directly underneath the section that is creating the shadow. Then, with a No. 4 brush, and using clean water, wash along this line and tilt the paper downwards. This will create a graduated form of shading— a technique which will be examined in more depth in Chapter 3.

Paint the trees, ivy, and bushes with a mixture of Olive Green, Burnt Umber, and Yellow Ochre, washing the mixture across the trees with a very wet No. 6 brush, and blotting the light areas again. Then, with the paint on the trees still wet, add a little watery Yellow Ochre to the tops of the trees and allow this to bleed freely. This technique will always add a highlight, or 'crown', to the top of the trees. The ground colours are, invariably, a full mixture of everything left on the palette, washed downwards across the paper.

The very final stage is to touch in a few lines with a pen. When, and only when, the painting is dry, certain lines that may need strengthening can be redrawn. The more paint that you use—this will generally be on the shaded sides—the more the ink lines may become a little washed-out. In this particular picture the only lines needing to be strengthened are those of the shaded side of the window frames, chimney pots, and the doorway.

This, therefore, is the basic introduction to the techniques that I recommend for painting buildings. Throughout the coming chapters, these techniques will all be elaborated on, and illustrated accordingly, as they apply to different types of buildings and situations.

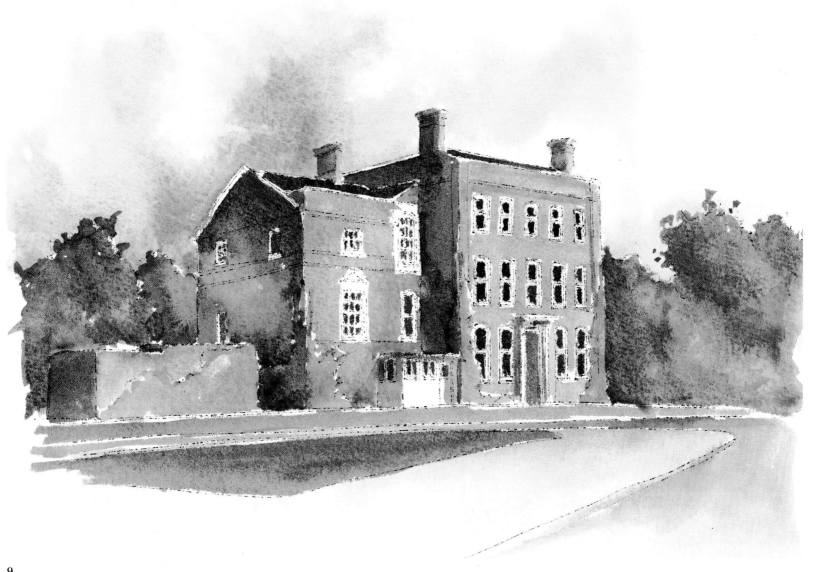

9

3

TIMBER-FRAMED BUILDINGS

Timber-framed buildings can be found in cities, towns and villages throughout the world, as wood is one raw material that has been available throughout history across the globe. In Britain, in particular, clusters have formed in certain areas—predominantly East Anglia, Kent and the south, and the Midlands.

Perhaps the only thing about timber-framed buildings of which we can be really certain is that they developed out of necessity. The smaller rural cottages were initially built on a wooden frame for the simple reason that timber was cheap and readily available and could, in fact, be cut from the forest and formed into reasonably-accurate lengths by the prospective house-owner himself.

In towns, the advantage was the speed with which they could be erected on-site. The timbers were cut, shaped in the carpenter's yard, and then numbered so that they could be assembled without confusion. (Have you ever noticed the numbers carved into exposed beams in pubs?) The wood was then transported to the building site, where the frame could be pegged together with wooden dowels and hauled up with ropes, often within the day. At a time of great commercial expansion (especially in the wool towns) ground was at a premium, and this method of construction must have been greatly appealing to the merchant with much business to attend to and little money to spare.

From the artist's point of view, there are several structural elements worth examining carefully in order to make sketching or painting all the more interesting.

First, many timber-framed buildings lean at seemingly alarming angles, making them all the more appealing to the artist on the look-out for the unusual. Several suggestions are offered for the peculiar twists and warps in these old buildings. One is that during the days of Elizabethan expansion, timber was in great demand as the forests of Europe receded under the woodman's axe. Speed, therefore, was all-important. Merchants were not prepared to wait for their homes to be built, and so wood was used immediately it became available. As these 'green' frames weathered, they twisted, turned, and warped under the pressure of the roof. Having seasoned and subsequently hardened, these structures soon became absolutely rigid, and may still stand today.

Another reason given for these misshapen structures is that, in Britain, the Elizabethan court required each district to supply the Crown with a certain quota of timber, to boost the construction of warships for the Navy. On decommission of these ships, a proportionate amount of well-seasoned but warped timber was returned to the district and was used by the carpenters for the construction of more homes.

For the artist, these wooden frames can produce a wealth of fascinating lines in the composition, and a variety of textures and materials between the wooden frame supports. In the earliest days of timber-framed building, wattle and daub was used to fill in the walls. As this rotted, it was replaced by the increasingly-popular and more readily-available brick, often set in a herringbone

pattern known as brick nogging. Painting the wattle and daub-type plaster, and washing and blotting to create the texture, is discussed in Chapter 4 (thatch cottages), and painting brickwork is dealt with in Chapter 6 (town houses), in addition to being discussed here; the main areas of examination are the wooden timbers and the tones, shapes, and shadows that they create.

At this point, therefore, it is important to examine the building style known as jettying, as this was responsible for showing the timbers at their best. This was very popular during the Elizabethan days, and involved building overlapping stories onto the ground-floor base, sometimes up to four stories high. Again, several reasons are offered for the development of this type of building.

First, Elizabethan sanitation took the form of little more than emptying buckets of household waste out of the nearest window. Consequently, it would be most advantageous to have an upper floor that overlooked the lower floor when it came to throwing out the rubbish. This also gave protection to the vulnerable passer-by.

Second, as was previously mentioned, land in towns was at a premium and was subject to a considerable tax. Consequently, if you needed to expand, the most sensible way was to build a second floor onto your house with a larger area than the one on the ground, thus evading any further tax and providing more room for the family in the process.

The third and most probable theory is that the Elizabethan architects became gradually aware of the concept of stress on beams. They soon understood that the beamed floors of their bedrooms were sagging badly when any substantial weight was placed in the centre. This can best be likened to a boarding plank, placed between a ship and the harbour wall, which will bend under the weight of anyone walking across it. This situation was soon remedied by taking the beams out across the top of the lower-floor walls and weighting them with the upper-floor walls, adding considerably to the stability of the whole structure. The exposed beams then became perfect subjects for the highly-skilled Elizabethan carvers to show their abilities on, producing some wonderfully-decorated beam-ends which are always worth close examination.

FIGURES 10 AND 11

The final historic point worth examining here is the positioning of these buildings. In the very earliest days of building, most small homes in England were built end-on to the road. Before jettying became popular, expansion meant the building of another house onto the side, forming an 'L' shape. This can clearly be seen in the centre of the illustration of Lavenham (Figure 10), where one particular house (probably the first one of the terrace to be built) stands end-on to the road, breaking the visual line, and making the whole structure all the more interesting for the artist.

These, therefore, are the chief architectural points that are worth bearing in mind when painting timber-framed buildings. Now let us consider actually painting these buildings.

The initial sketch for a row of timber-framed buildings will be considerably more detailed than that for many other types of buildings; the more exposed beams there are, the more there is to record. As windows will often have been added at assorted times during the development of these buildings, they will occasionally be irregular and of different patterns, and much time and frustration can be avoided later on if these are recorded accurately right from the beginning in the initial sketch (Figure 11). Frequently these buildings will defy the rules of perspective as they lean and twist, and for that reason alone may warrant a little more time given to this all-important starting point.

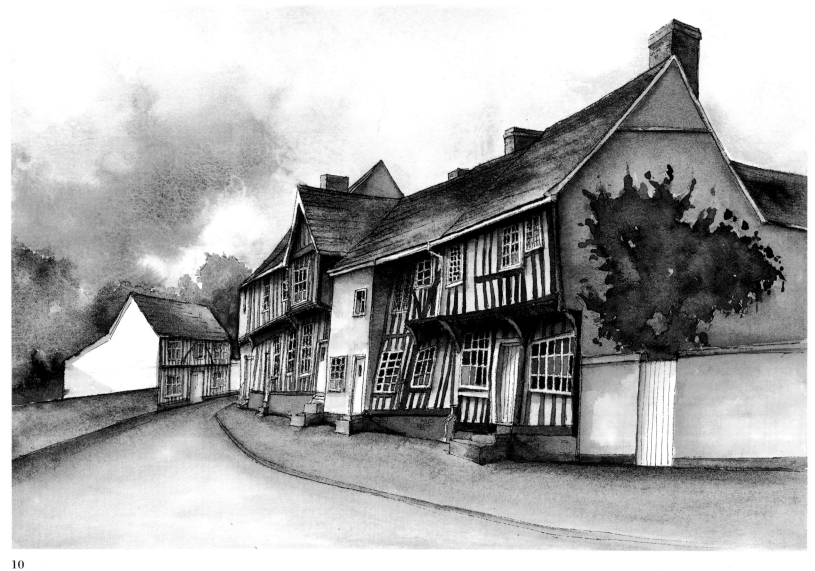

10

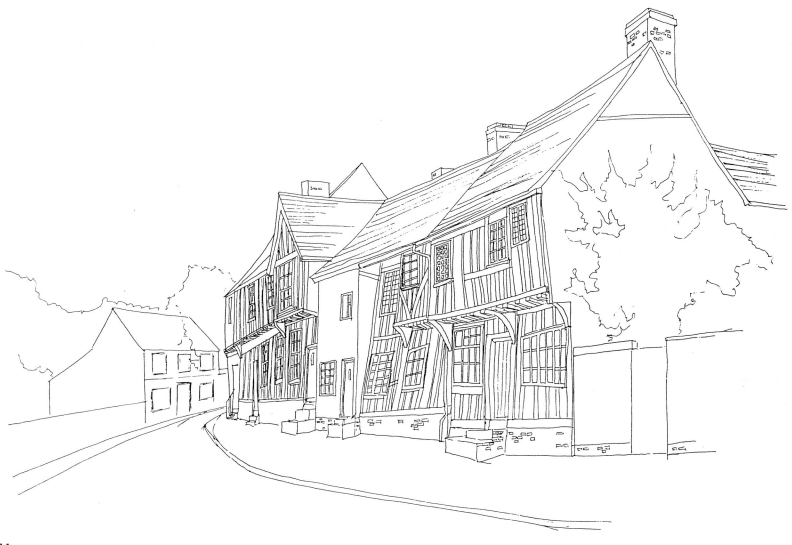

11

FIGURE 12

As always, the overall tone of the painting will be set as soon as the sky tone/colour is established. On the sharp spring morning when this painting was started, the sky was a deep blue with a bank of white cloud slowly moving across the horizon—an excellent day for painting, as the colours were accentuated and the shadows strengthened. Having started the initial stage of wetting the sky area and mixing the sky colours in the palette, the painting had begun (on this occasion I used 95 per cent Prussian Blue with only the slightest hint of Burnt Sienna). In this particular case, to prevent colour running onto the roofs, I turned the paper upside down and washed the blue paint across the sky with a No. 12 brush, leaving the cloud area untouched, as was discussed on page 18. Had any paint run into the cloud area, an instant blot with the kitchen roll would have prevented any damage being done.

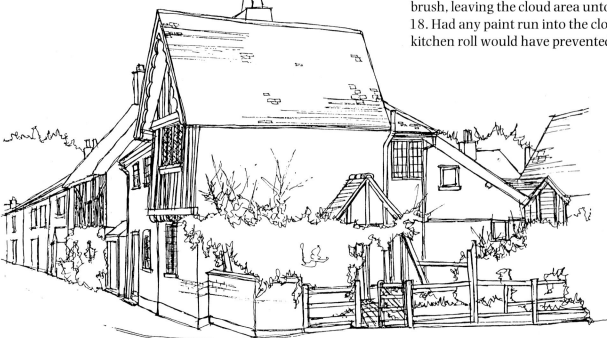

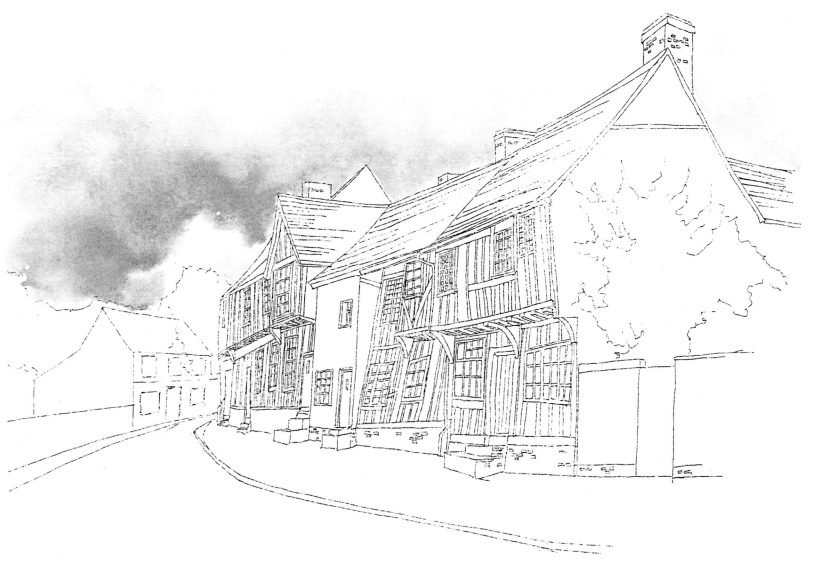

FIGURE 13

Having established the strong bright sky, the next stage was to cover the sketch with a basic undercoat wash, starting with the roofs. The old brown clay tiles of the foreground terrace roof caught and reflected the colour of the sky, subsequently requiring an unusual amount of blue toning. I generally use a mixture of Burnt Umber and Raw Sienna to suggest the warm tones of these old tiles, but the sharp intensity of the spring morning light required the addition of a substantial amount of Prussian Blue on this occasion. I then watered down the paint for the roofs and washed it across the dry paper with a No. 8 brush.

The interesting break in the terrace, as was previously mentioned, was not only structural but also tonal. The centre roof was tiled with more recent blue/grey slate, and I painted this onto dry paper with a watery mixture of Prussian Blue, with more Burnt Umber than was used in the sky to take the brightness out of the tone. A little blotting was required to establish areas of light tiles which are accentuated by the upward bulges in both roofs.

I then mixed together all the paint left in the palette, and washed it across the ground once with a very wet No. 12 brush, and allowed it to dry to its own tones. As this was still a basic undercoat, there was no need to worry about a variety of tones, as these will be developed in the following stages.

The main building colour in this particular case was not quite the Suffolk Pink to be examined in Chapter 4 on thatch cottages, but is still a tone frequently found on timber-framed buildings with exposed beams. This colour is a watery mixture of Yellow Ochre and Raw Sienna which I quickly washed over with a very wet No. 8 brush, taking care to avoid only the white window frames and doors. No attention should be paid to detail in respect of shading at this stage, which I concluded by washing in the red brick base with a Raw Sienna and Burnt Umber mixture, and the trees with a very wet mixture of Olive Green and (again) Burnt Umber. This will take only a matter of minutes to dry, especially out of doors, allowing you to move quickly onto the next stage— that of introducing some substance into the picture.

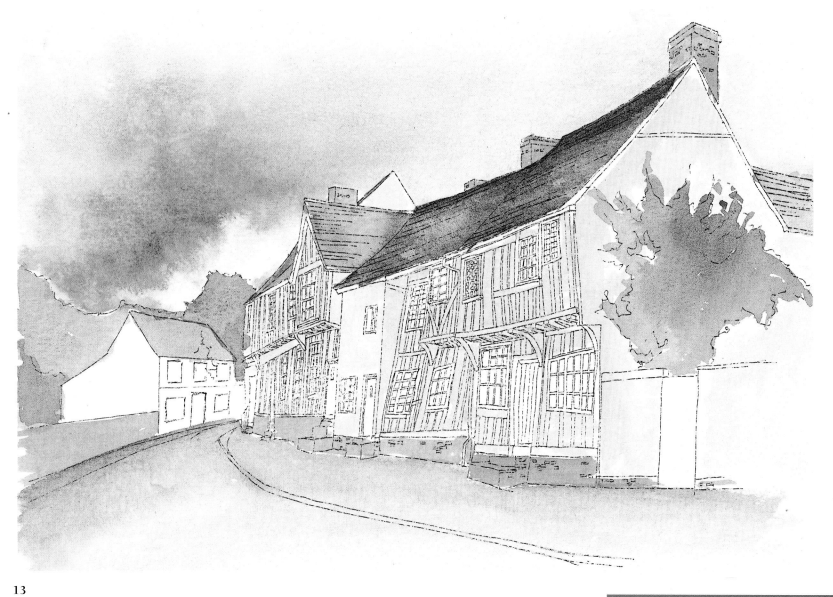

13

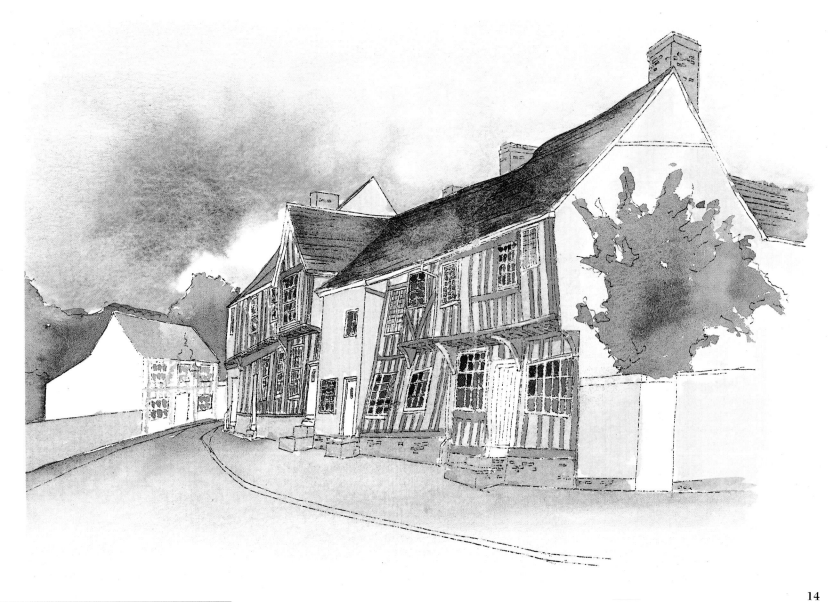

FIGURE 14

The next stage required a change of brush to a No. 2. Some exposed timbers are untreated and have faded through exposure to the elements over the years; others are tarred or stained black. But whatever tone they appear, a Burnt Umber base will always be appropriate. In the example of Lavenham, the beams were dark and required the addition of a little black to darken the tone.

One important point to remember here: although, as stated, many exposed beams are tar black, never use pure black to paint them. This will have a disastrous effect in flattening the whole composition, as it will not allow any shadows to be cast either underneath or to the side of exposed beams (black against black will simply look like one continuous tone). So, with the No. 2 brush, I painted the beams in one continuous dark brown tone.

This was also the time to paint the windows. As these were set at vastly differing angles, the reflected light was bound to vary in its intensity. Again, these should never be painted in tones of black alone. As the sky tone affects the roofs, so it must reflect in the window panes. The colour mixture on this occasion was Black and Prussian Blue, which I painted with a No. 4 brush, taking care to leave the white of the window frames unpainted.

FIGURE 15

Now it is time to examine possibly one of the most interesting aspects of painting timber-framed buildings—that is looking for the eaves, jetties, and nooks and crannies that create the shadows and the shading. Whilst at this point it is important that the entire picture should be shaded to add to the three-dimensional effect, Figure 11 shows the shading under the eaves and beams in particular. I achieved the overhanging effect by carefully painting a strip of black paint, mixed with a hint of Burnt Umber, directly under the protruding beams with a brush of either size No. 1 or 2. Before this had time to dry, using a wet brush (No. 6–8), I washed horizontally across the strip of paint. The dark paint then blended with the water and ran down the wall section of the painting on the slightly-angled paper. This also left a dark residue directly underneath the eaves/overhang. Whilst this technique is not unique to timber-framed buildings, it is used with great frequency when painting them and is, without doubt, one of the most interesting techniques with which to experiment.

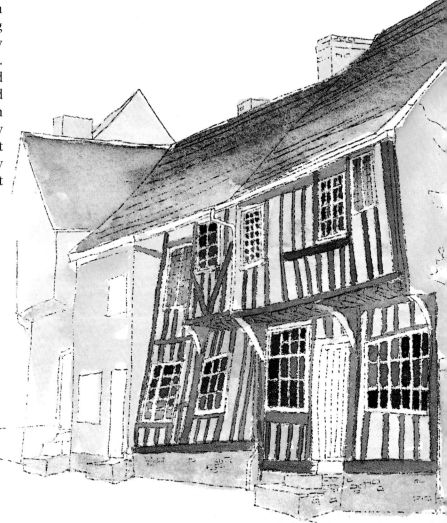

15

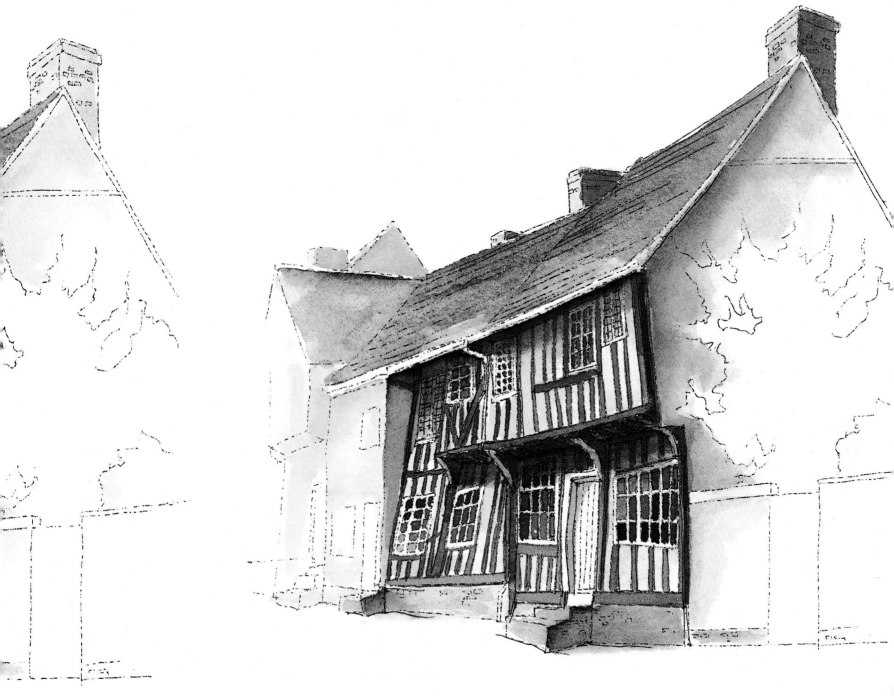

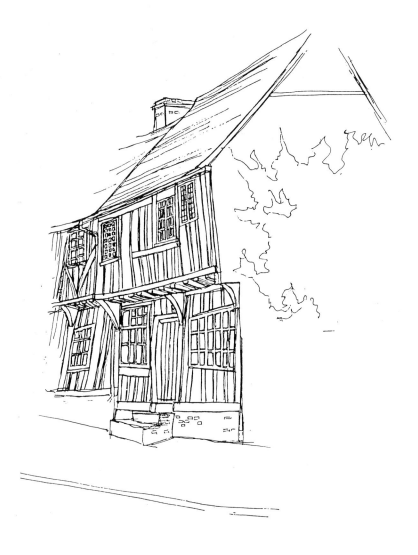

FIGURE 16

The final stage required to complete this painting was to add any finishing touches or details, and to pick out certain sections to be redrawn—chiefly the exposed beams and overhangs. In this particular example a very strong light was shining on the frontage of the house, casting shadows onto the right-hand side of the beams, window frames, and door frames. Picking out the lines on the dark side in ink helps considerably, forming a strong contrast between the left-hand side of a beam caught by the sunlight and the right-hand side cast in the shade, generally enhancing the overall sharpness of the picture.

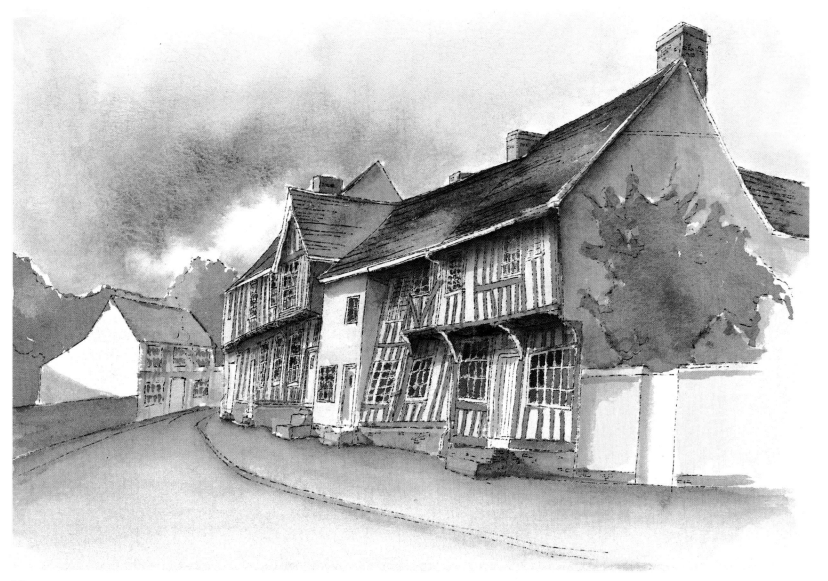

FIGURE 17

As was mentioned in the introduction to this chapter, timber-framed buildings can be found all over the world. Some of the grander types may be found in northern Europe, especially in German and Flemish market/merchant's towns. This particular painting of a north German market town serves to illustrate the building style that has come to be recognized and known as 'black and white'—a phrase that is, I believe, self-explanatory. The timber-framing here is an integral part of the structure of the building, and is not simply decorative, as is much of the black and white building to be found in the British Midlands, where 'half' timbers were often nailed onto the outside of brick buildings by the romantic Victorians, who longed to recreate the idealized Britain in their towns and villages. The in-filling between the timbers in this German village was brick, covered with stucco, or plaster, and whitewashed to please the ever fashion-conscious eyes of the burghers.

Whilst the phrase 'black and white' is useful and appropriate to the historian, it is, in fact, highly deceptive to the artist, as neither white nor black are required in any great quantity. The most important colour used in the painting of this building was Prussian Blue. The actual timbers were painted with 90 per cent Prussian Blue and a small amount of Burnt Umber, plus an even smaller amount of Lamp Black for toning purposes, painted onto dry paper with a No. 2 brush. Before this was allowed to dry thoroughly, the entire building was washed across diagonally with a wet No. 8 brush, resulting in a certain amount of light greyish-blue paint running across the white of the building. The purpose of this was to prevent an appearance of glare from the whitewash; an unblemished or untarnished brilliant white building may be appropriate on the sun-bleached coasts of the southern Mediterranean, but for a dull wet morning at a north German flower

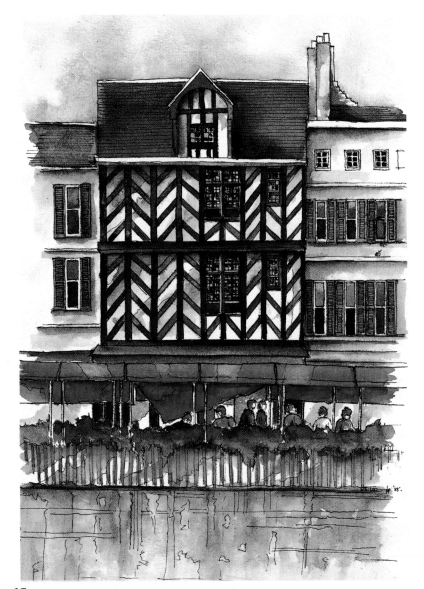

17

market, only a little white was required. The wet wash was then selectively blotted to achieve a patchy effect rather than an overall dull toning, again adding that all-important element of variety to the surface.

This technique was used again on the market stall aprons. Just before the red paint had time to dry fully, a water wash was applied diagonally, and blotted selectively. Some of these blots were then highlighted with pen to suggest folds and creases in the fabric rather than just patches.

This particular picture was painted with the kind permission of a stall-holder under his awning, as the drizzle would have given a totally new meaning to the term 'watercolour' had it been attempted out in the open!

The wet-look effect on the foreground was created by the application of a lot of water to a sloping paper. This bleed was started by selecting the colours that stood out most in the reflections in the puddles and rain-soaked ground. The red of the market-stall awnings and the bright yellow highlights in the flowers seemed to register visually as the most obvious and prominent colours to use. These colours (Winsor Red and Brilliant Yellow) were applied in the same tonal strength, in the appropriate places, as they appeared in the awnings and the flowers; this looks quite awful, at first, but is soon remedied. Then, immediately, a substantial clean water wash was run along the colours just applied with a No. 8 brush—the paper was tilted so that the water ran vertically down the sheet. The tones were now watered down and appeared considerably lighter. Some selective blotting took place here, and, when fully dried, some bleeds were emphasized with a few vertical lines just to reinforce the effect of the reflection.

18

FIGURE 18

Another great wood-building country is America. This particular illustration of a wooden town house in Colorado is typical of the Colonial style of timber-framed buildings to be found across the USA and Canada.

This timber cladding, or weather-boarding as it is often referred to, is a delight to both sketch and paint. In the initial sketching stage I always gain much pleasure from quickly sketching in these long 'scratchy' horizontal lines to represent the individual planks of wood. The very nature of the watercolour paper and ink pen drawing combination will assist the technique of the scratchy broken line, whereas a full strong set of lines representing the planks would look far too heavy and would detract from the wealth of tones that can be introduced to these wooden walls with paint.

The usual technique of painting a line along the underside of the eaves was used here, only on this occasion the wash that was pulled down across the rest of the walls also served as the main wall colour, eliminating the need for an undercoat of paint. No blotting was used on the main bulk of the building (with the exception of the tower) in this particular painting, as the wash-down from the shading was quite adequate on its own.

The shading on the tower and its turret, however, is graduated and requires special attention. This technique will be dealt with in greater detail in Chapter 9 on working buildings, but is largely self-explanatory: that is, the side nearest the source of light is the lightest, and the side farthest from the light source is the darkest. Here there is one middle stage in between, which was painted first of all with a basic colour wash (in this instance a very watered-down mix of Burnt Umber with the slightest hint of Prussian Blue). This was to form the middle section which was, in fact, facing in the same direction as the front of the house, and so would logically

be of that same basic colour. The far side facing the light was immediately blotted to create the lighter section, and when dry, the other side was painted over, once again, with the basic colour mix. When the colour has fully dried into the paper this will have the effect of darkening the tone. Finally, a few carefully-selected lines on the shaded areas of the house were picked out for strengthening, emphasizing the contrast.

CONCLUSION

Timber-framed buildings do need particular attention in the early sketching stage, as the very nature of these warped old buildings dictates careful observation of their peculiar structures. Look carefully under all eaves and beams, and particularly under jettied sections for the all-important shadows, and use the technique of washing the shadows down the wall to create the graduated effect.

— 4 —

THATCH COTTAGES

Thatch is perhaps the oldest and most traditional form of roof covering to be found on buildings and is, I believe, almost uniquely British. I have travelled widely in Europe and America, and have rarely witnessed such extensive use of thatch outside Britain, that is with the exception of Iceland, where I did see a couple of nearly-thatched barns. However, the thatch cottage is, without doubt, very much a part of the British heritage, and many are, fortunately, still to be found nestling in the rolling British countryside and amongst the picturesque rural villages. They are not difficult to find and many have managed to retain the rustic charm of years long since past.

Unlike the fashionable homes of the landed gentry who were for ever obsessed with fickle trends, and built their homes around the most contemporary designs, the thatch cottages were the homes of labourers and the working classes who had neither the time nor the money to be influenced by the vagaries of London fashion. Their homes were functional and built out of what was available at the time, and at a price that was affordable. In the lowland areas of East Anglia, thatch is as prominent as the reeds on the Norfolk Broads and the low-lying Fenlands. In Kent, the wetlands of Romney marsh provided a ready supply of raw material. But perhaps more important than its instant availability was the fact that the raw material was free.

As time passed, the Victorian architects, in conjunction with the moralists of that generation, began to open their eyes to the ugly spread of the fruits from the seeds that they had sown in unbridled industrial developments. Whilst they had no wish to check the growth of industry, they felt the need to redevelop the tiny hamlets that had been deserted for the city employment prospects, and so the 'model village' was born. Soon these began to spring up around the country—picturesque little cottages in neat ordered rows, often with highly ornate and decorative patterns woven into the thatch. Some of the more unusual had particularly non-functional shaped roofs. More often than not, these were built on the approach roads to a large estate so as to impress the drivers who travelled through to the main manor house. They now provide some of the most picturesque and attractive buildings, in some of the most relaxing and restful environments in which to paint.

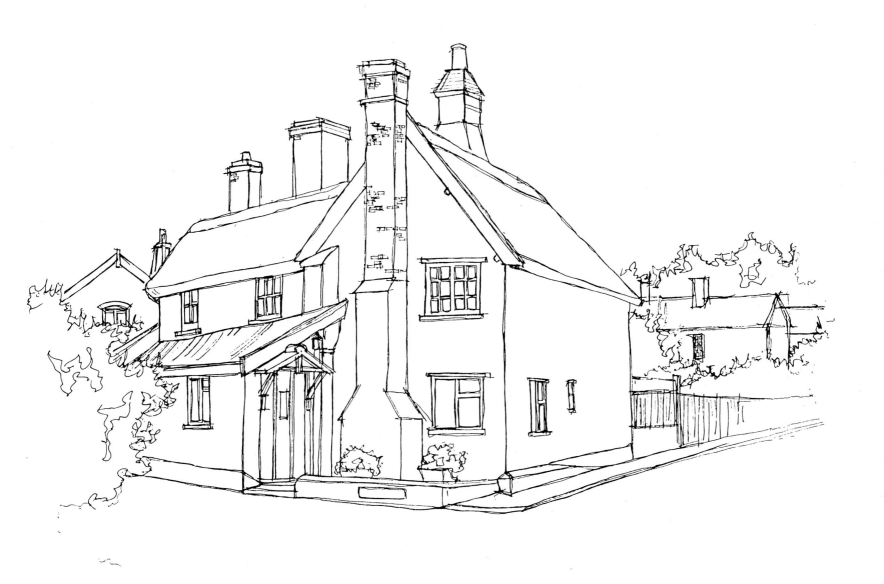

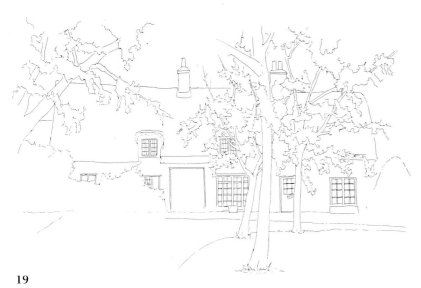

19

FIGURE 19

This particular thatch cottage in Suffolk is certainly a genuine original untouched by the Victorian planners. In this composition the surroundings and natural foreground play a vital part and need to be examined as seriously as the cottage itself. This was painted during a mid-spring Sunday. The foliage on the trees was thick, but not thick enough to obscure the view completely. Consequently, all of the foreground had to be taken into account in the initial sketch, which included all the main obvious features, such as windows, doorway, and of course the trees.

I find it useful sometimes to pick out the largest of the shaded areas within the trees and to sketch these with a few quick lines. The only real danger is that the urge to carry on drawing overtakes you, so that you end up with much more than a simple line sketch. So exercise some self-control!

FIGURE 20

As usual, the sky was soon established with Prussian Blue, then washed and blotted in order to capture the large white cloud above the crown of the roof.

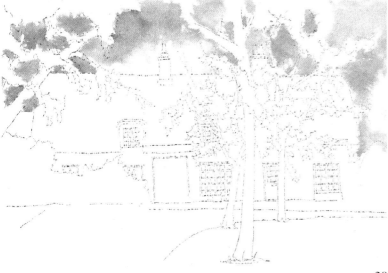

20

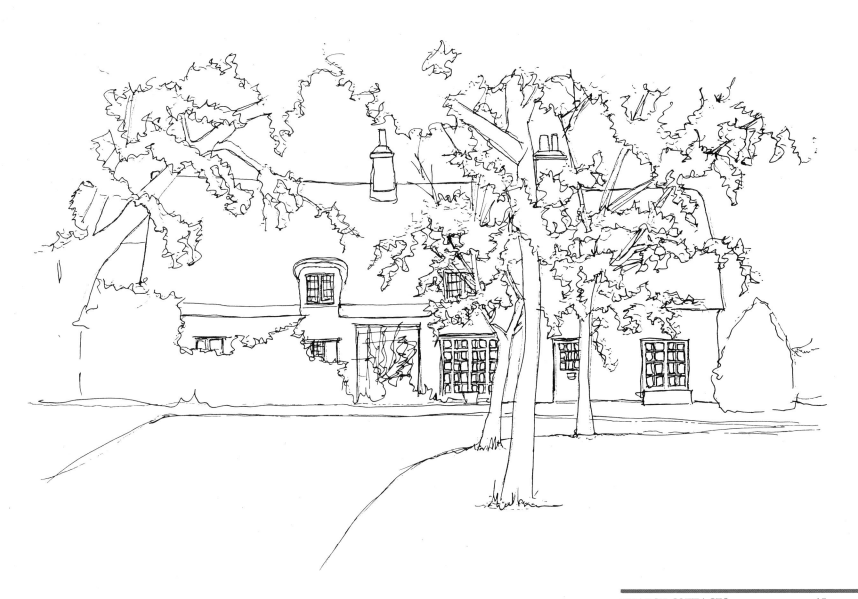

FIGURE 21

The next stage was to develop the basic building colours and the all-important foreground colours. This required wetting and blotting in succession on this particular painting to build up the variety of tones required.

First the thatch roof was soaked and a wash of Yellow Ochre and Burnt Sienna (and occasionally a hint of Prussian Blue) applied along the top of the thatch, allowing the paint to run downwards. Here I had the option of blotting out any highlights or lighter areas of thatch that were strikingly obvious, or letting the bleed produce some aesthetic qualities of its own, which may be perfectly acceptable.

Many thatched country cottages will have some form of plaster on their walls, often whitewashed or painted an attractive tone known as Suffolk Pink (which is, incidentally, found far outside Suffolk). Several suggestions as to the origins of this mixture can be discovered at the bars of rural Suffolk pubs. The two most reliable are (1) that villagers, who were tired of the traditional lime and water mixture, took to crushing berries into the mixing pots just before the annual whitewashing of the outside walls to add a little more interest and impact to their homes. Less pleasant but equally acceptable is the explanation (2) that bulls' blood was mixed into the whitewash prior to painting. Bulls have always been a symbol of rural strength, and the bulls' blood was considered to have given that same strength to the walls of the house—and who can argue with the makers of houses that are still standing today!

However my Suffolk Pink mixture is made up of Winsor Red and Yellow Ochre. In this picture the mixture was washed onto a dry surface and selectively blotted in parts to create some texture within the walls. Most plastered cottages will have patchy plaster, stained either through damp, an accumulation of grime, or simply old age. Blotting helps to establish that type of texture.

Now, working towards the foreground, the trees, foliage, and lawn were all treated to the same technique of wetting and applying an immediate colourwash made up of Olive Green and Yellow Ochre (with perhaps a little Burnt Sienna), allowing the paint to bleed into its own shapes. This required a little intervention on my part by moving or angling the paper, directing the paint into the areas I wanted covered, and blotting those sections that I wanted to act as highlights within the trees. The last part of this particular stage was to paint the wood of the trees using a Burnt Sienna and Prussian Blue mix, blotting out the edge facing the light source (in this particular case the left-hand side), leaving the other side with a shaded appearance.

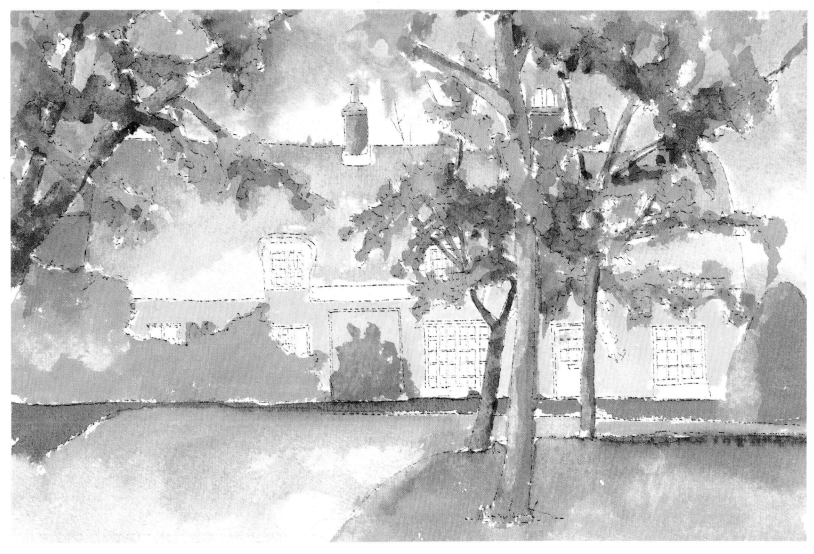

21

FIGURE 22

With that stage complete, the painting was beginning to take shape, but required considerably more depth in the shading and the addition of some warm ground colours. In most cases, shadow painting is simply a case of mixing the particular paint required and increasing the amount of the darkest constituent colour. In the thatch in Figure 22, for example, the shadow cast by the dormer window is attained by increasing the level of Burnt Sienna and painting this onto the already-established colours.

Dormer windows are frequently found in thatch roofs and are worthy of special attention when you are painting shadows. Always look in three places: first, on the outside, as they will be shaded on one side; second, underneath, as they can often cast very strong shadows onto the walls, and finally, look inside. As is evident in this particular picture, they will often cast shadows across the white wood boarding into which the window frame is set. Little touches like this are important in making the picture come alive.

The shadows under the eaves, however, were painted with a Suffolk Pink mixture, plus a very small amount of Lamp Black for toning, which was run along the underside of the eaves and washed downwards with a wet brush. As the shading on the building was mottled (shadows cast by trees frequently have this effect), much wetting and blotting was done in rapid succession to achieve this.

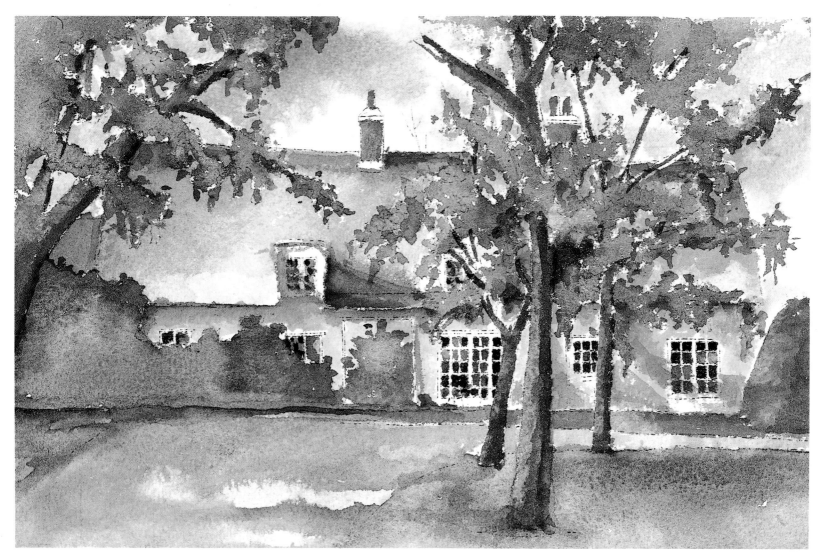

22

The penultimate stage was to work on the all-important fore-ground. Regarding ground shadows, a dark wash of your ground colour onto dry paper with a No. 8 brush will create a very definite and distinct shape. This application of paint will require a graduating wash only if the shadows are particularly weak that day. On a bright spring day, a sharp shadow should require no further painting.

The ground in this picture, however, did! The day was warm and the season was well in progress. To capture the warmth and mood of the day, I added a mixture of Winsor Red and Yellow Ochre to the watery mix of ground colours in the palette and washed this across the foreground, again washing and blotting in rapid succession to achieve the mottled shading that you can always expect to find wherever there are any trees in close proximity to your chosen site.

One last bit of colour had to be added to bring this picture to a stage of completion, and that was the reds in the flower borders running along the front of the cottage. These were applied with a very wet No. 2 brush and allowed to bleed freely onto the greens of their bedding.

Whilst this set of illustrations has shown the basic colouring likely to be encountered when painting thatch cottages, I have not yet examined the shapes of thatch roofs and some of their special features that are worthy of the artist's attention.

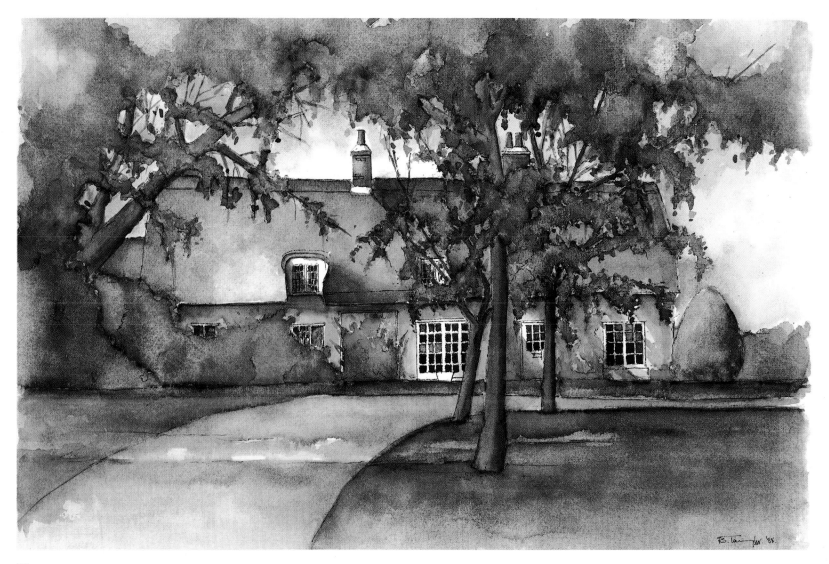

23

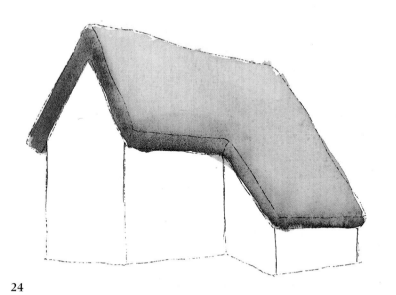

24

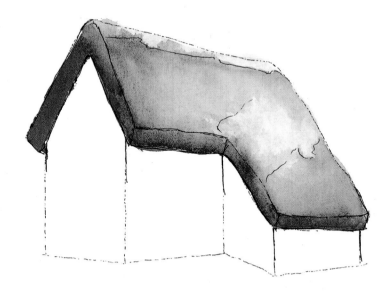

FIGURE 24

This figure illustrates two main techniques. First, if you apply paint to a wet area, it will invariably run down to the bottom of that particular area, stopping at the first area of dry paper that it reaches. Here the accumulation of paint will dry, resulting in a darker 'rim' along and around the bottom of that section. This is just the technique to employ when painting thatch roofs, as the bottom, or edge, of the thatch will often be in the shade.

Second, if you blot out a ridge along the top of the roof to form the 'crown' of the thatch, blot out any more highlights or light patches that appear, and finally overpaint the edges of the thatch, you will have mastered the skill of thatch painting. The only other remaining detail is to underline the 'crown' in pen to emphasize it a little more.

FIGURE 25

This simply illustrates a selection of the more typical types of thatch roofs that you are likely to come across in your travels.

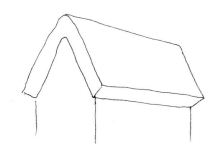

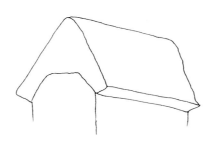

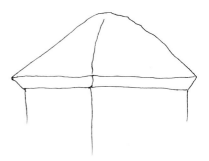

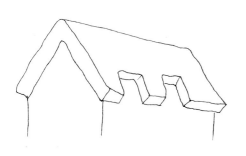

25

FIGURE 26

This illustration of Kersey in Suffolk serves to reiterate the points made previously about blotting highlights and the 'crown', and shading the exposed thatch edges. One of the main pleasures to be found in painting the traditional British thatch cottage is in the even more traditional country gardens that so often surround them. The blaze of colours to be found in the cultivated rows, and in the wild edges and hedgerows, are a delight to paint and are also great fun to experiment with. In fact, I believe that they are more suited to being recorded in watercolour than in any other media available to the artist.

Although no hard and fast rules or advice can be offered regarding the mixing of natural flower colours, as they are so varied, I can explain my approach to painting them. This technique needs to be one of the finishing touches to your painting (unless the flowers are so prominent as to take over the entire garden) as it involves letting colour bleed onto the background foliage. The mixture that I have used is a combination of Winsor Red and Brilliant Yellow.

The technique that I use for applying these colours is as follows. First, I turn the picture upside down and, with a very wet brush (probably a No. 6), run the paint along the bottom of the flower bed. The colour will then bleed in a skywards direction across the background foliage, as is the case in this particular illustration. In the case of a non-specific flower border, or a hedgerow with wild flowers growing amongst it, this may well be all that you will need to do to create the impression of a colourful patch of growth.

For more specific or taller-growing flowers, the same technique applies, but with the addition of a little extra! When the paint of the flower colour bleed is nearly dry, turn the picture back to its proper position and apply a few small dots of bright colour (whatever that particular flower colour happens to be). This should then bleed downwards, but will maintain a 'head' for the flowers if your timing was right and the paper was not too wet. This is the particular skill that is great fun to experiment with, but will take a couple of attempts before you get it absolutely right. The purple tones of the tall bush were mixed from Winsor Red and Prussian Blue, and were included from the very beginning, as they formed such a prominent part of the composition.

One other potential difficulty encountered here was the wealth of dark and lush green tones required for both the foreground and background. Many subtle adjustments were required here to complete the balance between the highlighted and the shaded areas of bush, grass, and trees. This was achieved by both wetting and blotting in succession, always blotting the top sections of the bushes and trees as they caught the light, and shading the undersides of these as they were shaded.

This is a very suitable point to introduce the *push-pull* effect: anything can be made to appear lighter, not by actually altering the tone in any way, but by making the areas around it considerably darker. This will visually 'push' the tones forward and make them look as if they are lighter. This trick was used in this painting to make both the bush on the left-hand side of the cottage, and the hedge just in front of the large background tree stand out. I had highlighted both of these by intentionally making the sections behind them considerably darker. This technique is not, of course, restricted to painting foliage, and will be of much use when working with any set of objects that are of a similar tone.

Different greens were required to separate the grass from the bushes, shrubs, and trees. I use considerably more Yellow Ochre for lawns, as they tend to take on a straw-type tone during the height of the summer, whilst the trees still maintain the lushness of their growth and the richness of their tones.

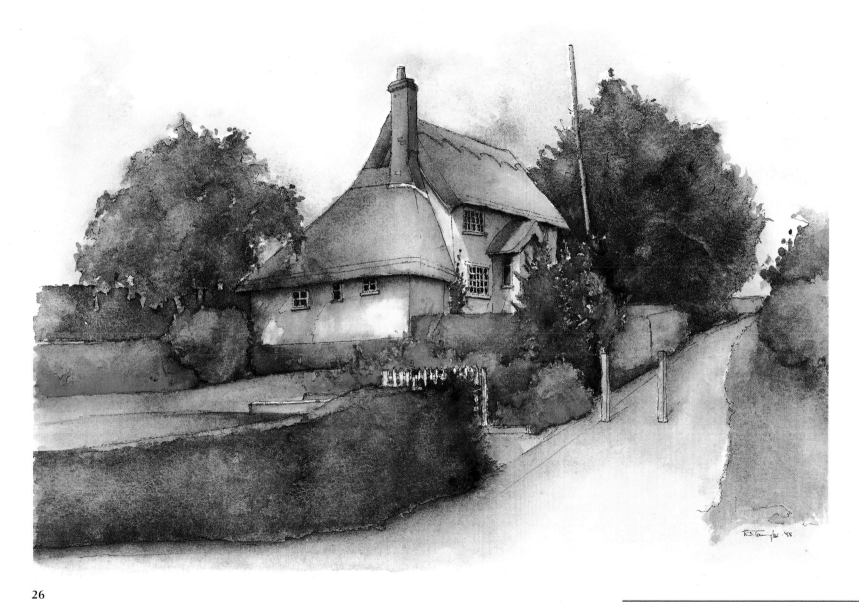

THATCH COTTAGES 55

FIGURE 27

This painting of a thatched Scottish Highland croft was as much an exercise in recording the wet lushness of the Highlands after a storm as it was one in recording the thatch croft. This picture was painted from under a rather rickety stone barn with a rusting corrugated roof; but the protection it afforded allowed me to be there as the rain storm passed, and to complete the picture as the storm clouds rolled off over the horizon and the sunlight broke through to catch the tops of the rolling hills in the distance. Should you ever wish to paint in the Scottish Highlands, I doubt that you will have any difficulty in witnessing such scenes—the rain storms occur with a dampening regularity.

The thatch on the roof also took on a radiant glow as the sun caught the fully-soaked crown. This effect was captured by the addition of a little more Yellow Ochre than usual, and an instant blot along the crown to remove as much paint as was possible before it dried. The pure white of the building was used, once again, to highlight the strength of the sun, and was simply left for the white paper to show through (this is the brightest white you will ever attain with watercolours—no blotting, just pure plain white paper). The same treatment was given to the posts and poles.

The ground colours were treated to a great quantity of water in the washes. The far distant hills were unusually, but on this particular occasion necessarily, painted with an Olive Green, Yellow Ochre, and Brilliant Yellow mix. Brilliant Yellow is not a paint that I would generally use for ground colours, but the wetness of the grass and the sharpness of the light dictated its use this time. Burnt Umber was added to the middle-range hills to create the dips, and the darker ground with a little purple (Prussian Blue and Winsor Red) added to the immediate foreground as a wash. The general tone of the day, and the thin covering of wild heather, were the reasons for mixing purple into the wet grass. The foreground was then given a thoroughly soaking wash taken from the remaining ground colours in the palette, and the watercolours allowed to find their own way down across the paper, forming their own shapes, shadows and textures.

One other notable feature of this painting is the sky. This also has been subjected to the push-pull treatment, whereby the distant hills are made to look lighter by increasing the dark tones in the sky. I painted the sky in the usual manner by wetting the sky area and applying the paint onto this wet surface. In this particular case the paper was turned upside down, the paint applied along the horizon-line and left to bleed into its own shapes.

One other feature introduced at this point was the smoke rising from the chimney pots. On this occasion the smoke was lighter than the sky, which necessitated blotting out the shapes that the smoke was forming. This effect can also be achieved by rubbing away a small plume of paint with the edge of a clean eraser, but the blotting technique is more likely to look convincing.

CONCLUSION

Always look to the crown of the thatch, and be prepared to blot it quickly. Foreground colours are prevalent, and the scene will often be set by the brightness of the English country garden.

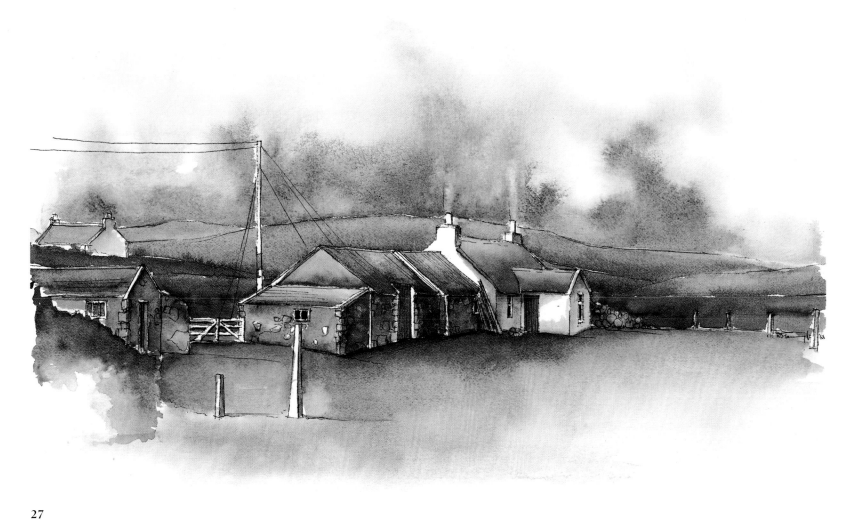

27

= 5 =

STONE BUILDINGS

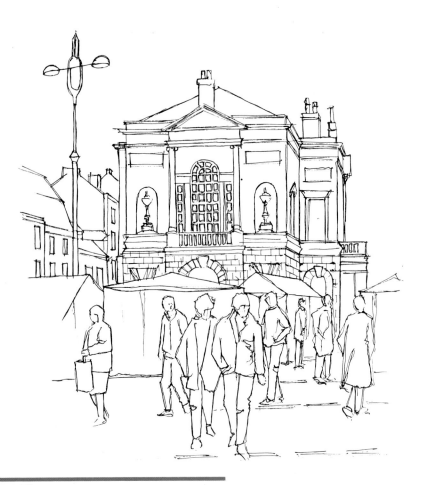

Stone is, perhaps, one of the most popular non-pliable building materials, second only to brick. Its wide use is due to its availability, accessibility and cheapness throughout the world.

Stone buildings can generally be placed in three categories:

Ashlar—this involves building with large square or rectangular blocks of stone which are laid in an even, rectangular pattern

Coursing—here the stones are not necessarily of exactly the same size or shape, but are laid in distinct courses

Rubble—this is where the stones are laid at random with no real attention being paid to the aesthetic qualities at the time of building. These buildings, in particular, were practical and purely functional, but, ironically, provided us with some of the most visually pleasing buildings and are certainly one of the most interesting groups to paint.

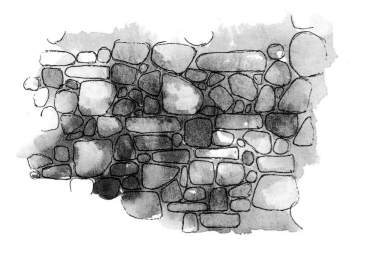

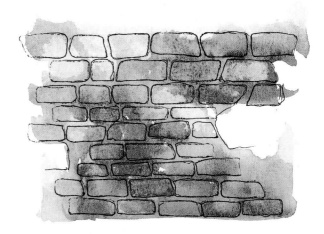

28

F I G U R E 2 8

This illustration shows examples of coursing and rubble. The general method used for painting both types of stone is as follows.

At the initial sketching stage, do not be tempted to overdraw (which is very easy to do when you have a set of small positive shapes to focus on); always make sure, in fact, that you 'under draw' the sketch, leaving plenty of room around the stones. Next, mix your basic stone colour—which will generally be a mixture of Prussian Blue and Burnt Sienna—and wash this across the sketch with a very wet brush, and blot.

The possibility exists at this stage either to blot some of the stones already sketched, or to blot at random and simply see what happens. The latter may well result in some interesting shapes forming that you can actually draw around and 'convert' into ready-made stones.

Another possibility exists here for you to introduce different tones into specific stones in order to highlight the irregularity of the surface. As the cement in between the stones is invariably lighter, this technique of painting-in specific stones is beneficial to the over-all look of your building.

Keystones are another important feature to be considered here. These are to be found on corners or edges, and are frequently considerably larger than the rest of the stones in the adjoining wall or building. They are also a very useful starting point for perspective constructions.

FIGURE 29

This particular example is typical of the rows of stone terraces to be found in northern England. The corner building is a common feature, and served here as an excellent starting point.

The very first stage was to position the corner line slightly off-centre; this then acted as an 'anchor' from which all the perspective angles radiated outwards. Interestingly, the perspective is created not so much from the converging angles on the roof-tops as in the slope in the road. In fact, there is very little linear perspective used here, as the houses are stepped as they follow the line of the road; so it was the bottom line of the buildings, and the line of the road, upon which all the attention was initially focused.

Sitting in a position, opposite a corner, will often allow you a wide-angle view of the scene as it disappears out of your line of vision to the left and to the right. This, in turn, allows you to develop the perspective in your foreground with a few sharp, appropriate lines in the road. In this case I used what I will often refer to as a 'trick' to increase the depth of vision, by taking the lines in the road from virtually under my feet, round in a sweeping curve, disappearing out of the far left-hand side. (There will nearly always be markings on man-made roads, if only owing to the amount of wear over the years that they endure. Ridges in tarmac, dips and even official paint markings can all be used as lines to follow visually.) Of course, this is not a view that you would naturally see, but it does increase the perspective and enhance the over-all effect (and ultimate success) of the painting.

The lines of the roofs did appear to converge slightly with the line of the road, and were sketched in accordingly. Having sketched in the keystones as they alternate on the left and right sides of the building, and a few of the selected ashlar blocks and the other vital bits and pieces, the painting process may be begun. One other set of features that is worth recording at this point are the blocks of stone that surround (or even form) the windows. They are a common feature in stone buildings and are as important as the brick window surrounds in town houses.

Stone, like brick, is very susceptible to atmospheric conditions and can glow with the mid-day sun, or seemingly absorb the wetness of a late autumnal rain shower—as was the case on the day that this picture was painted. The blue/grey slate of the northern quarries dictated a large amount of Prussian Blue in the basic colour mixed, and only a small amount of Burnt Umber to tone it down. This was washed onto dry paper, and blotted quickly in parts to create the wet-look on the roof. This paint mixture was reversed for the brick work (i.e. more Burnt Umber than Prussian Blue), but several layers were eventually applied. This first, very wet layer was washed across the entire length of the terrace with carefree abandon (well, nearly), avoiding only the white of the window frames and doorways. This dried quickly, giving a reasonably even, but very light, all-over tone.

The next stage was to fill in the main block shadows, adding weight to the linear perspective, and establishing the two directions of the terrace. This was quickly followed by the technique that I enjoy most of all when painting with watercolours—that is, washing and blotting with different tones to achieve a vast range of subtle tones along the stone walls. As was described in the earlier part of this chapter, some of the stones that had already been sketched-in were selected for additional toning with an assortment of light and dark brown. The blotting that had previously taken place had created some attractive light patches which served as additional highlighted stone areas. These two together started to form a most attractive and realistic-looking ashlar stone wall.

The diagonal, or streaked, shading was introduced as a result of the way in which rain water was drying onto the stone, and was representative of the angle at which the torrential downpour that

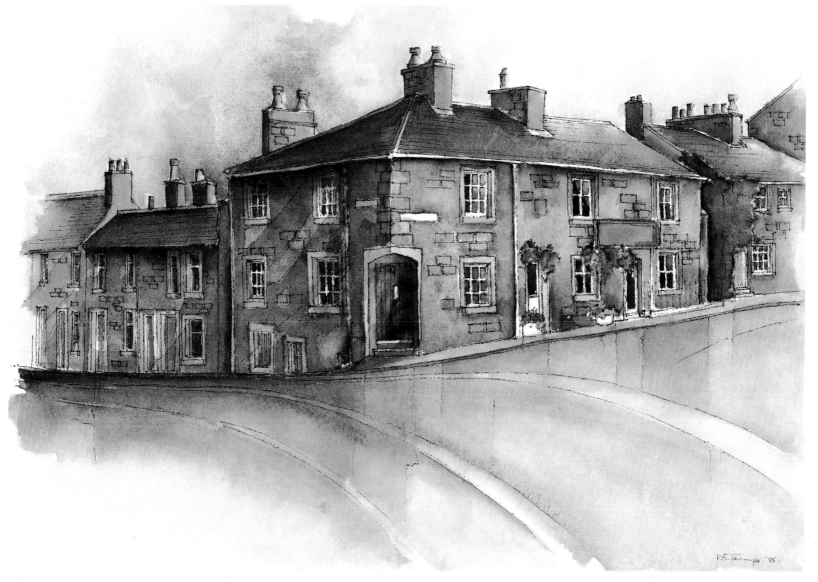

29

had just occurred had hit the walls! The final touch to complete the wet-look was in the road. Unusually, here I actually soaked the road area with clean water before applying any paint. A dark mixture of Prussian Blue and Burnt Umber for the ground colour was washed under the base line of the pavement and left to run downwards. Instantly, some selective areas were blotted vertically to create the effect of puddles and reflections. The colours reflected from the hanging baskets were also added to bleed into the ground colours. The shapes in between lines that were drawn right at the beginning were also blotted, adding some tone and subsequent visual weight to the already-established linear perspective. A few vertical lines sketched in along the shape of the reflections added a valuable finishing touch.

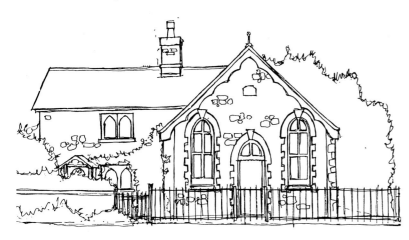

F I G U R E 3 0

The other example of a British stone building that I have included here is a rubble-built cottage in Cumbria. Idyllically-positioned between the Lakeland pine forests and a gently running stream, this building was more of a pleasure to sit and paint than many.

The late evening sun bathed the entire landscape in a soft near-purple glow, although the air maintained a distinct chill.

As with the last illustration, the alternating corner stones (they are prominent on all types of stone buildings) on the facing edge of this farmhouse extension made an ideal starting point for the sketch, and provided a solid guide by which to cross-check the straightness of the other vertical lines. In this particular sketch, any attractive or interesting groupings of stones were picked out and recorded (that is, any that formed unusual shapes, had a particular tone, or were grouped into contrasting shapes or forms).

The entire building was washed in the constituent stone colours as usual, and then the purple toning was added while the paper was still wet, allowing the bleed to develop and spread in its own way, and then blotted accordingly. The purple mixture was made from Prussian Blue and Winsor Red, and it was very much a part of the atmosphere of the evening. The wash was also added to the trees and the ground, both in the background and the foreground, as well as being encouraged to run into the sky by my holding the paper upside down.

One particularly interesting feature of this building was the plastered and whitewashed wall. Here again, the paper was held upside down, and a shading tone applied between the two extensions, and washed towards the roof with a very wet No. 8 brush. The wall area was immediately blotted to maintain some white, but allowed to dry in patches which were later picked out in pen.

The running water in this picture required particular attention. Initially it was painted with a very light and watery mix of the basic ground colours, and then blotted horizontally, along the line of the water's natural flow. The darker sections were then darkened even more, to increase the contrast, by the addition of (again) the purple wash. As soon as this was dry, a few of the darker sections were picked out with vertical pen lines.

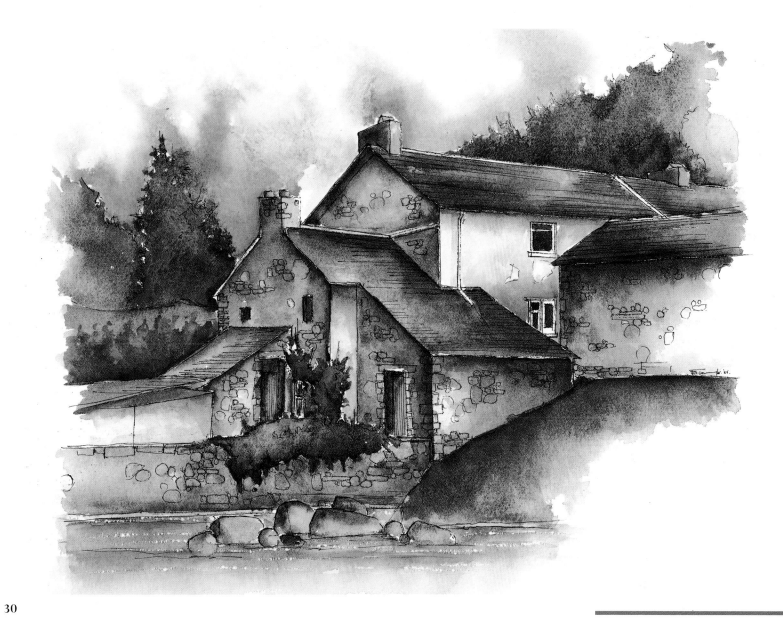

The wetness of surface water and puddles will always be represented by short vertical lines; running water, however, should always be represented by longer horizontal lines following the water's pattern of natural movement. The addition of vertical lines to a river or stream will give the impression of reflections (which can really only occur on still waters) and will have the effect of slowing down its appearance. The illusion of movement can be enhanced even more by scratching the surface of the paper with a pin or the point of a compass. This will lift the surface of the paper, leaving a string of white flecks, representing the ripples and breaking surfaces associated with moving water.

FIGURE 31

As was previously mentioned, stone buildings can be found throughout the world, and some of the most picturesque and unusual European examples are to be found along the Rhine Valley. This area of sheer cliffs and natural beauty, born in primeval days as the powerful Alpine waters carved their way through what was then only a gap in the hills, is steeped in history. It harbours romantic tales of human use, abuse, habitation, and cultivation, spanning centuries. Many of the fairytale castles and châteaux still stand, but many more have been reduced to shells, and stand only as ruins today. These homes that stood so proud on the lofty crags were generally built of Alpine granite, and were often the haunts of robber-knights who used them as bases for their attacks on shipping.

During the medieval period, West Germany was not the united country that it is today. The powerful local barons set up trade barriers, and needed bases from which to control these. The castles were often built for defence purposes also, and were frequently scenes of much brutal fighting. The medieval atmosphere still hangs heavy in the air in this part of the world, even today.

This next illustration is a sketch in every sense of the word. This particularly elegant and lofty château on the banks of the Rhine was sketched and painted within the hour as the last rays of the evening summer sun were fading, bathing both building and surrounding foliage in a warm, yet pale, orange light. The shadows were long and strong, and the highlights equal in their strength. It was, without doubt, an evening of contrast and subtlety—an interesting mix for the painter to play with.

As speed was a prime consideration, certain decisions had to be made as to what was important to the overall impact of the picture, and which parts were not important enough to be included. This is never an easy choice to make, but one you will be forced to make quite frequently, and one for which your ability and skill will soon develop with time, patience and practice.

In the initial sketch, only the bare minimum was included. The ornate decorations on the turrets, and the elaborate brick coursing on the chimney pots, gave way to the positioning of the windows in the curiously-sculptured towers, and the accurate recording of the turret and tower roofs and pinnacles. The shortness of time available applied to the painting also, so I denied myself the luxury of an undercoat, and adopted a principle that if I mixed the colours to a considerably greater tonal strength than was really required, then when they dried to a much lighter tone (as I knew they would) the result might be just about right.

The sky was washed with Prussian Blue, selectively blotted, and then quickly washed again with a mixture of Winsor Red and Yellow Ochre, to record the atmospheric glow of a soft sunset. The roof was then painted quickly onto dry paper, drying quickly and flat as a result. The multi-sided turrets were painted using the same method as that described for painting the wooden-boarded house in Colorado (Chapter 3), i.e. blotting the side facing the light and darkening the shaded side, leaving the middle to take care of itself.

As has been emphasized frequently throughout this book,

31

shadows and shading should always be graduated with a wash. Now, however, we have come across one of those 'except for...' situations. With a very low sun casting shadows onto a round, light-stone tower, a very positive line will occur, as is the case here. The shading on the round pinnacled roof is graduated, as is the shading for the tower itself; here, however, it comes to rather an abrupt halt in a very neat geometric curve (which also helped to emphasize the round shape of the tower). The shadows from the chimney pots and the turrets required no subtle blending with a wash either: the shadows were simply so strong that evening.

Next I painted the foliage. Again, no undercoat was possible, and so just a straightforward 'wash it on and see' technique was used. The natural colours of the ochres and purples in the trees were caught and accentuated by the evening sun. After the main colour wash onto dry paper, establishing the basic warm greens (achieved by the addition of more Yellow Ochre than usual), a selection of reds, purples, and oranges was immediately applied with a very wet brush and allowed to bleed freely. In the last few moments of natural light remaining, I redrew the lines on the shaded side of the building to strengthen the overall effect. The sketch, both in pen and paint, was then complete.

FIGURE 32

This group of old stone farm buildings on the French Pyrenees was painted in the warmth of a long lazy Mediterranean afternoon. The sky in this picture is probably brighter than any other in this book, and is mixed with little else than Prussian Blue, and perhaps a slight hint of Yellow Ochre. The roof-tops were covered with the red tiles so often associated with southern Europe, and the shutters on the windows hung lazily on that warm afternoon.

As this particular group of buildings forms more of a composition than single buildings or even terraces, particular care had to be taken with the initial sketch to ensure that everything fitted together, rather like a jigsaw puzzle. One tip that is useful here is to look in between shapes of visually-interlocking units—chimneys, roofs, extensions, etc. The angles that they form will be crucial to your composition, and are probably the reason that you considered the group appealing to paint in the first place. Visually, this composition dips into a distinct 'V' shape just off-centre, along the line of the roof-tops, with the three triangular gable shapes from the bottom of this 'V' shape moving upwards towards the left-hand corner. All of these are visually interlocking, and are worth seeing as such when sketching. The keystones also come in useful again here as an 'anchor' to focus on when sketching.

The painting was quick, easy, and enjoyable. The warmth of the stone was achieved by a mixture of Yellow Ochre and Raw Sienna, tempered only with a hint of Prussian Blue and Burnt Umber for shading. The roofs were nearly pure Raw Sienna, again with only a hint of Burnt Umber. But by far the most enjoyable part of this composition for me was painting the bright red poppies that grew wild in the foreground of the field. First, the field was washed with a basic ground colour of Olive Green and Yellow Ochre, but with a considerably strong dose of the latter. Immediately, before it had time to dry, a stronger mix of Winsor Red, with only a hint of Yellow Ochre, was washed along the top of the field, underneath the wall, and allowed to bleed freely, drying in its own shapes.

CONCLUSION

Do remember to look for keystones in the initial sketch, and be prepared to wash and blot quickly; this should give you some stone shapes to highlight that you had not sketched in initially, and may well prove to be more interesting in the final result.

— 6 —

TOWN HOUSES

I suppose it must be true to say that the development of the brick town buildings generically referred to in Britain as 'Georgian' was a direct result of the Earl of Arundel's visit to Italy with his accompanying artist, Inigo Jones. Unusually, Europe was at peace, allowing a considerable flow of ideas, and the subsequent spread of the arts, throughout the Continent. People, too, were travelling freely, and eagerly absorbing all that they saw.

When Inigo Jones and the Earl of Arundel were on their grand tour of Europe, they became acquainted with an Italian named Palladio, who had made a serious study of the classical arts of Ancient Rome—notably the sculptures and the building styles. These he recorded with enthusiasm and vigour, documenting the mathematical proportions and the visual harmony that had been achieved by the builders of Ancient Rome. This information he processed and personalized, eventually producing an architectural style, still recognizable throughout Europe today and known as Palladian. Jones was greatly inspired, and recorded the visual ideas that he saw with a vigour equal to Palladio's. He returned to England with great plans and enthusiasm for his new architecture.

In 1666, the Great Fire of London swept through the timber-framed buildings and soon wiped out an entire era of architecture. London had to be rebuilt, and the aldermen of the City were very receptive to any new ideas, especially those that made concessions to fire-proofing the next generation of buildings.

The chief innovation that Jones and his supporters had to offer was that of brick—a fire-proof material that was becoming increasingly inexpensive to produce (see Figure 33). The second innovation was the terrace—an economical way of building individual houses with fire-retardant features included, which, in turn, affected the overall design. And finally, and possibly more important than anything else to the artist, was the visual harmony through symmetry that Jones saw in Italy amongst the great palaces and wished to introduce into the domestic buildings of London (as well as other cities, towns, and large villages). These issues will all be discussed, with their relevance to the artist, in the following sections.

This chapter is best served by three illustrations to encompass all of the building styles and facets that the artist is likely to encounter anywhere in Europe.

Let us first consider the classic Georgian town houses, usually three-storied, red-brick, and originally perfectly symmetrical, prior to subsequent owners adding wings and extensions. These homes are predictable. They were built on a simple block plan, with the hall and the staircase occupying the centre, with windows directly above the door to provide lighting for the stairway. As was previously mentioned, the concept of 'visual harmony through symmetry' was the catch-phrase of the day and was adhered to rigidly. To achieve this level of harmony, domestic buildings were designed on a 'unit plan', the unit generally being a cube on which everything else was modelled; so windows, doorways, and the

spaces between them were all balanced and related to the harmonic proportions of the cube.

FIGURE 33

This particular example in Dedham was obviously built for the landed gentry, copying the buildings so favoured by their peers in London. The main consideration at this point is the brick, and the most suitable methods of representing large-scale brick buildings in paint.

BRICK

From the artist's point of view, one historic development worth noting in particular is that brick was still expensive and building costs were affordable to only a few. The Napoleonic Wars placed an even greater demand on home-produced raw materials, and consequently the cost of building increased rapidly. The solution used by many land developers was to off-set the expense of materials by employing unskilled (and therefore considerably cheaper) brick-layers to work on the basic construction of the building, and to employ expensive skilled craftsmen for a short period only to complete the brickwork at the front of the property which was on show to the world, and, consequently, the most important part. For this reason the brickwork on the front and sides of detached buildings will often look different.

The beauty of these old clay bricks is that their tone can change to such extremes under different atmospheric conditions. On a late autumnal afternoon, when bathed in strong sunlight, they can glow with a warm orange radiance. Equally, they can assume the dull grey of a damp February morning with as much ease. So observation of colour is important.

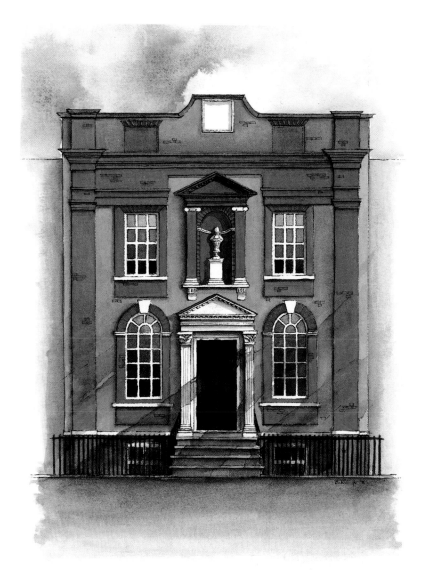

33

As I mentioned in Chapter 2, my basic brick colour is a mixture of Burnt Sienna and Burnt Umber, to which I add more Sienna on a bright day and more Umber on a dull day. Occasionally, in a city or grimy town, a little Prussian Blue is required to tone down the brickwork, but this will be discussed in greater depth in the section on terraces later in this chapter.

As the buildings are so large, and so many brick courses have been used, it is not usually possible to paint in every brick, and so a technique of 'suggestion' needs to be introduced. There are no hard and fast rules governing this technique—it is another one that needs to be practised and one for which (just as with perspective) you will very soon develop an eye. It simply requires you to pick out a few bricks here and there within a wall, and highlight them either with paint, or with a pen, or even both. Sometimes this is made easier for you by the brick patterns on the

window surrounds, and by the occasional burnt bricks that will inevitably be visible in any brick structure.

FIGURE 34

These show this technique in stages. First, having established the correct brick tone, wash the paint onto the dry paper using a wet medium-sized brush and allow to dry. As you will by now be aware, this will dry to a slightly lighter tone than required which, in this case, is not such a bad thing to happen. This will allow you to move quickly onto the next stage, painting the exact tone onto the basic brick undercoat. This will generally be achieved by darkening the mixture with the addition of a little more Burnt Umber. Paint this on with a small brush (No. 1 or 2); this will, again, dry quickly, especially in the open air. The final stage here is

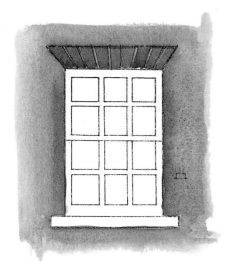 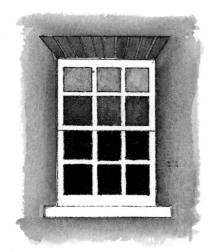 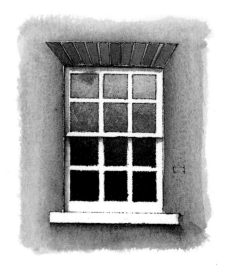

35

to pick out the selected or burnt bricks either with a paint mixture with more Burnt Umber added, or with a pen, or, as previously mentioned, with both for real impact.

WINDOWS

Windows and their shapes are the subject for examination in the next section of this chapter, as they do form the most visually-striking aspect of the standard Georgian house. As was mentioned in the introduction to this chapter, the Great Fire of London was, in part, instrumental in establishing the design of town houses. Prior to the Fire, wooden window frames were set onto the wall, and protruded outwards, sometimes by 3 to 4 inches (7.5 to 10 cm). After the Fire, legislation was passed requiring that all wooden frames be set well back into the walls, leaving no wood protruding,

and hopefully going a good way to preventing the spread of fire along a terrace.

Another significant development that occurred around this time was the sash window, which allowed adequate ventilation within the prevailing sense of visual order.

FIGURE 35

This illustrates the most usual types of windows to be found in town houses. When painting these windows, it is always import-ant to examine the way in which they are set into the wall, as shadows will be cast onto the top and onto one side of the wooden frame.

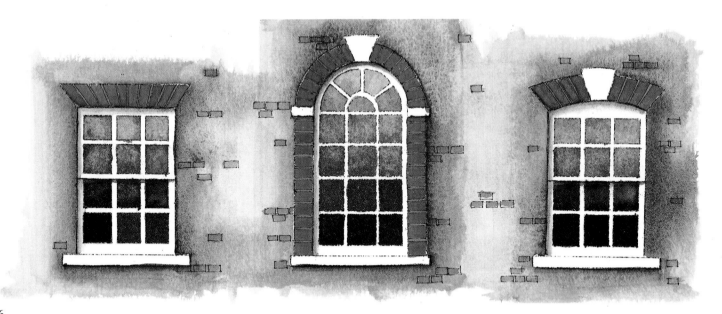

36

This illustrates a technique for painting these windows. First, establish the colour to be used on the glass, making sure that your choice reflects both the sky and the mood of the day. This will usually require a mixture of Prussian Blue and Lamp Black; remember, though, that black can flatten a picture easily, so use it sparsely and only for toning purposes. Paint this onto dry paper with a No. 1 or 2 brush, taking care not to paint over the white wooden frames. This should dry quickly.

The next stage is very similar to that examined in Chapter 3 on timber-framed buildings for shading underneath beams and overlapping stories. Establish exactly from which direction the light is coming. Then, with a thin brush and a small amount of Lamp Black and Burnt Umber mixture, paint a thin line around the inside edge on which the shadows will be cast, including the top of the frame. Before this has time to dry, with a wet No. 4 brush, wash along the line from the top, around the edge, down to the bottom of the frame. This will cause the dark paint to bleed, forming a shadow in the recessed window frame and adding to the three-dimensional look of the overall composition. This is the technique which is also appropriate for painting doors and doorways.

THE TERRACE

The next section in this chapter examines the other chief legacy of the Georgian builders—the terrace. As the classical ideas of Renaissance Europe spread to Britain, the design concept of the continuous Italian terrace quickly became popular in the highly fashion-conscious city of London. Again, these terraces are the result of both European influences and post-Fire legislation.

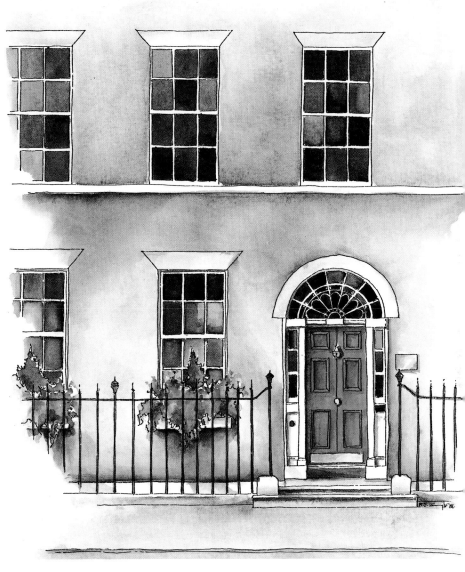

FIGURE 37

In this particular example of Bedford Square in the Bloomsbury district of London, the parapet wall running the length of the terrace was another move towards fire retardation by shielding the wooden roof beams. Before the Great Fire, individual buildings of any size could be erected anywhere, but the development of the terrace required some positive thought and forward planning.

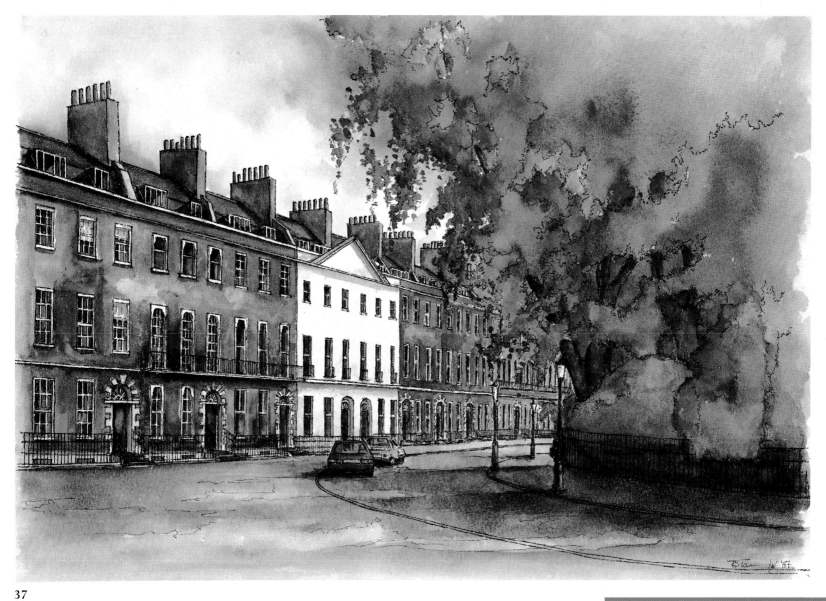

37

FIGURE 38

When painting these buildings, the key aspects to be considered right from the beginning are scale and perspective. Both long terraces and tall four-storied buildings need serious attention at the initial sketching stage. Unlike rickety rural cottages, town buildings tend to stand solid and upright, so, as again mentioned in the introductory chapter, always make sure that your vertical lines are parallel, with special reference to door and window frames and chimney pots. Also ensure that your horizontal lines converge equally.

Your sketch need not include anything more than the basic outline, windows, doors, and balconies, where appropriate. Railings, and any other features that will need little more than a pen line to indicate their existence, can be added as a final detail. Towns and cities also have their foliage, and this should be included at this stage.

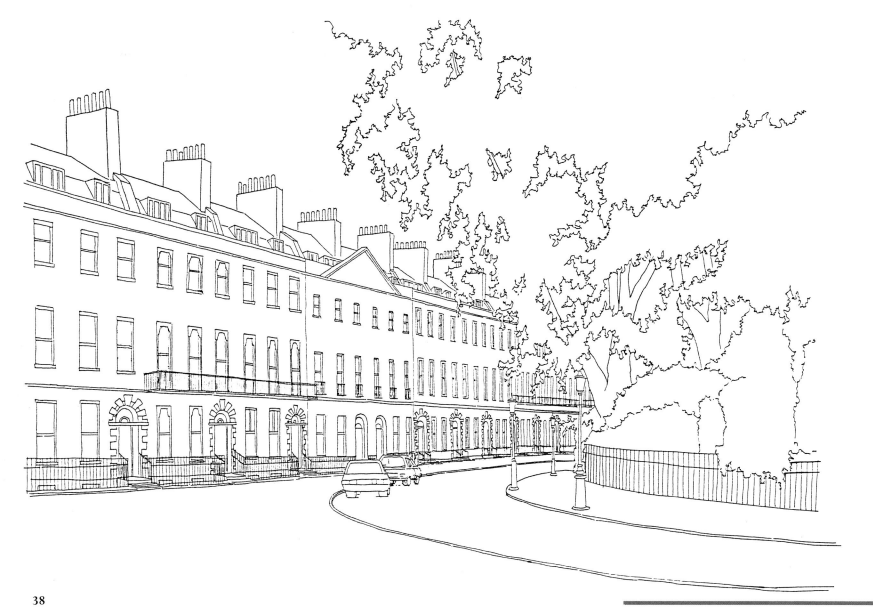

So with the sketch complete, it is time to begin the painting process. I always like to include an area of sky in my town paintings, as I feel that this helps to create the atmosphere of the day. My basic sky colour is, as always, Prussian Blue with a small amount of Burnt Sienna—this tint will frequently be 'reflected' in the brown of the bricks in the buildings. Using a large brush (No. 12), give the sky a good even covering of water, although not necessarily soaking it. This is important to allow a free flow of paint over the sky area. Wash the paint on instantly, tilting the paper if you wish to form some cloud shapes. The paint will then run (in whichever direction you decide), leaving areas without paint to form the clouds. Should these shapes not be quite what you hoped for, then blot out the appropriate areas with kitchen roll.

Having established the basic tone of your picture with the sky, which will ultimately decide the subsequent strength of the shadows, it is time to move on to the building and the all-important ground colours. The colours that you already have on your palette will serve you well for much of the composition.

It is important to consider, at this point, that many town and city buildings will, over the years, have been exposed to vehicle fumes and the general level of grime in the urban atmosphere. This will give most buildings a standard base colour which can be applied to every feature.

Slates and tiles will often have a brown/grey look to them. This you can achieve by simply reversing the sky mixture, starting off with the Burnt Sienna and adding a small amount of Prussian Blue. The smog-stained brickwork often needs a 'cold' treatment; for this use Burnt Sienna, Yellow Ochre, and again a small amount of Prussian Blue to maintain the tonal balance. Paint the trees with a mixture of Olive Green, Yellow Ochre and Burnt Sienna.

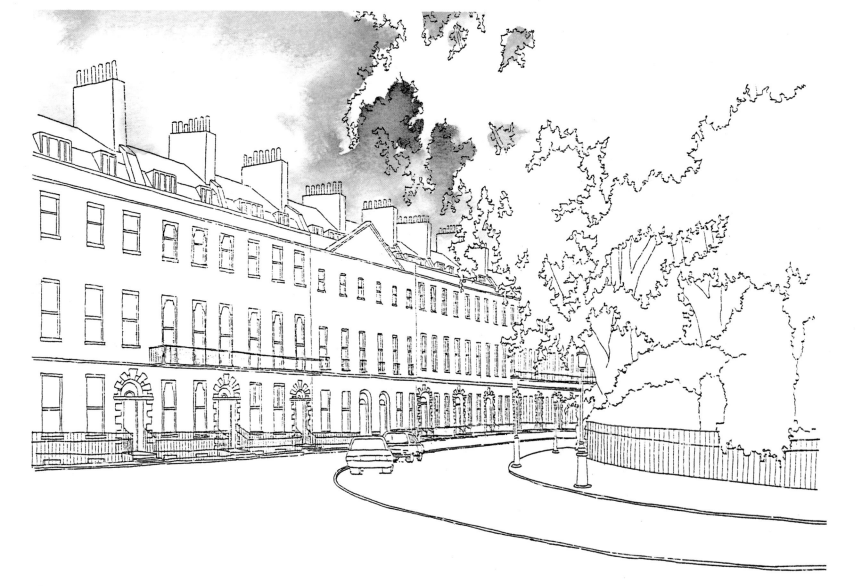

FIGURE 40

This illustrates the next stage of development, requiring wetting and blotting in succession. The priority is to complete the roof. First, wet the roof area with a No. 8 brush, then very quickly apply the wash of Burnt Sienna and Prussian Blue (watch out for the ridge-tiles—they may be of a different tone) obtaining as smooth a flow as you can.

Next you can approach the walls. On a large-scale terrace it would not be feasible to give consideration to individual bricks, so the method of 'suggestion' described earlier needs to be employed here, breaking the monotony of an overall tone. This is achieved by wetting and blotting. After wetting the main bulk of the building(s), apply the Burnt Sienna, Yellow Ochre, and Prussian Blue wash, taking into account two factors: first, that highlights and patchy, stained brickwork can be suggested by blotting the appropriate patches, and second, that tonal perspective is a consideration. The far end of the terrace, as well as having less detail, will also be lighter, thus increasing the perspective effect, and enhancing the range of tone on the walls; so blot this end also.

The ground and foliage are the final part of this stage. The trees are, as previously mentioned, Olive Green and Burnt Sienna, wetted and blotted to pick out the highlights. Use a mixture of all colours to achieve the dull grey of the city pavements. Again, highlights and shadows can be attained by wetting and blotting, allowing the paint to bleed into its own shapes—perhaps with some intervention on your part. But don't be hasty! Sometimes shapes will form as a result of water action on the paper, creating an image that is more pleasing than one that you would have controlled.

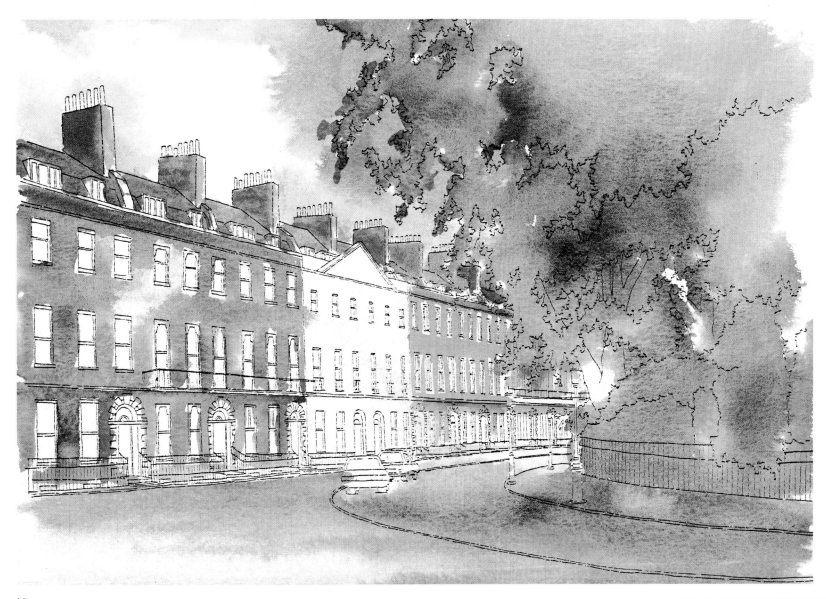

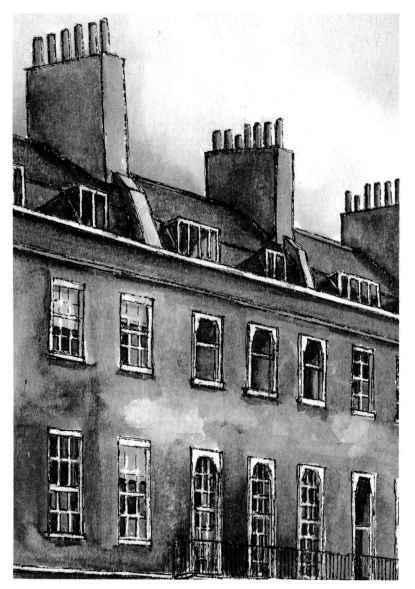

FIGURE 41

The painting is now be taking shape, but requires more depth. Figure 37 shows how this is attained by the addition of shadows which will, in turn, emphasize the highlights. Here it is essential to pay special attention to the assorted architectural features of town/city buildings—ridge-tiles on roofs; pediments; ornamental ledges; balconies; and inset window frames—all of which will require shading, or will cast shadows. In most cases, to paint these is simply a matter of increasing the amount of the darkest constituent paint—it is the application that requires attention.

Let us take the balconies on this terrace as an example. Mix the brick paint, and apply it in a straight line with a No. 1 brush onto dry paper, directly under the balcony; then wash it downwards with a wet No. 6 brush, graduating the shading onto the wall.

Ground shadows are also important, and a dark wash with a No. 6 brush onto dry paper will form a very positive and definite shape, as this will not run. Again, the final stage is to pick out the details with a pen; balconies, ridge-tiles, windows, etc. will all require attention.

In addition to these influences from the English and the Italians on the designs of town and city buildings, the Dutch also had their contribution to make. As a result of the immigrant wool-makers from the Netherlands settling in eastern Britain and on the northeast coast of America, the popularity of the gabled roof has spread far and wide. These gabled roofs, designed initially to protect the roof tiles from destruction by the strong winds that prevailed in any lowland areas, soon became an art form in their own right, adding a delightful appearance to many otherwise dull terraces.

Amsterdam is the apotheosis of the gable-fronted house. The terraces that line the long canals in Old Amsterdam seem to exude charm and colour and to highlight the greyness of the British city terrace.

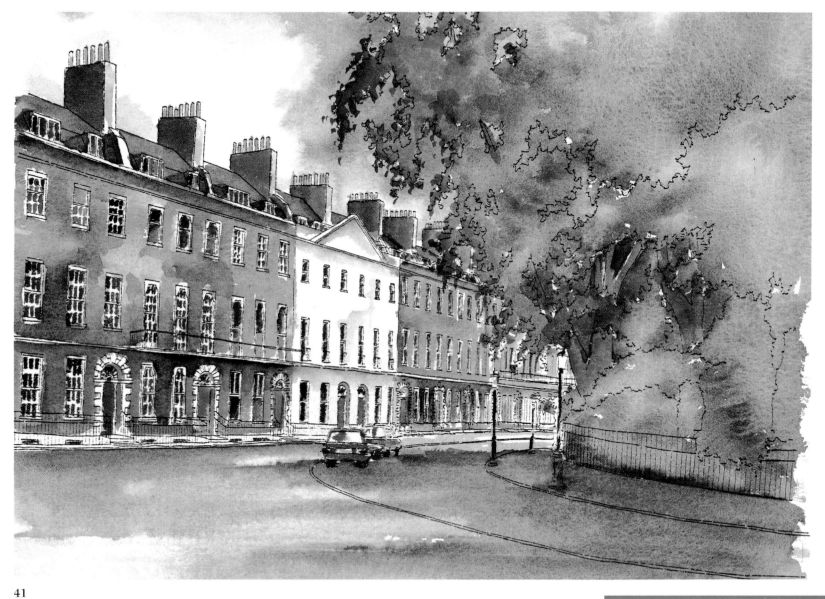

41

FIGURE 42

This particular example was painted from the far side of the canal on a sharp spring morning. The brick looked warm, though the canal still retained its coldness. The effect of moving water was created by scratching the paper with the point of a compass. This technique resembles light catching moving ripples of water and is a useful skill to have that takes very little mastering.

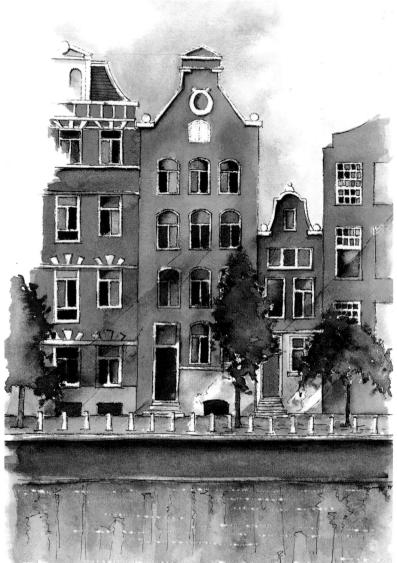

42

43

FIGURE 43

This shows three different types of gables that you are likely to encounter. Let me first offer two points for your consideration when painting gabled buildings. First, the gables' decorations and ledges will usually be white and will stand out against the sky. Sometimes it may be necessary for you to use a little artistic freedom or licence, and darken the colouring along your skyline a little to make them stand out; this is a perfectly acceptable practice and is frequently employed by all types of artists. Second, these decorative gable ledges will cast shadows which will require painting with the same techniques used for shadows under window ledges, i.e. painting a dark line directly underneath the ledge and washing it downwards with a wet brush.

CONCLUSION

The brickwork on Georgian town houses requires special observation and will often be affected by the atmosphere of the day. Windows will be set into the walls and the resulting recesses will require shading.

Terraces will need specific attention paid at the initial sketching stage to ensure that all vertical lines really do stand upright, and the brickwork will often be engrained with city grime, requiring the appropriate paint mixture.

WATERFRONT BUILDINGS

One of history's most effective, useful, and convenient bases of transport for both people and goods has been water. Canals, sea routes, waterways, and natural and man-made rivers have all served to boost economies and to aid travel and trade. Many of the buildings on these waterways that were once so valuable for commerce (notably warehouses) are now being converted into residences, especially in those cities with major waterways, like London and New York. Across the world, water networks have been established and many different types of buildings, including warehouses and cottages, have been built along their banks to house the workers and to serve the industries. For practical purposes, the majority of these buildings have been built of stone, as any other material would not have been sufficiently durable to withstand either the battering of the sea, or the constant eroding action of the inland rivers.

Two of the major characteristics of waterfront buildings are their height—often being multi-storied, to enable the occupants to avoid the dampness by living on the second or third floors—and the colouring that invariably occurs around the water-line where a mould or weed has grown, or the tide has worn a clear strip into the stone.

FIGURES 44 AND 45

This particular row of waterfront buildings on the River Lot in France displays most of these characteristics: they are five/six stories tall, are stained by many years of damp mould creeping up their walls, and are also scarred by the rise and fall of the water level (albeit non-tidal) during the winter and summer seasons. The technique for painting these buildings is illustrated in Figure 45.

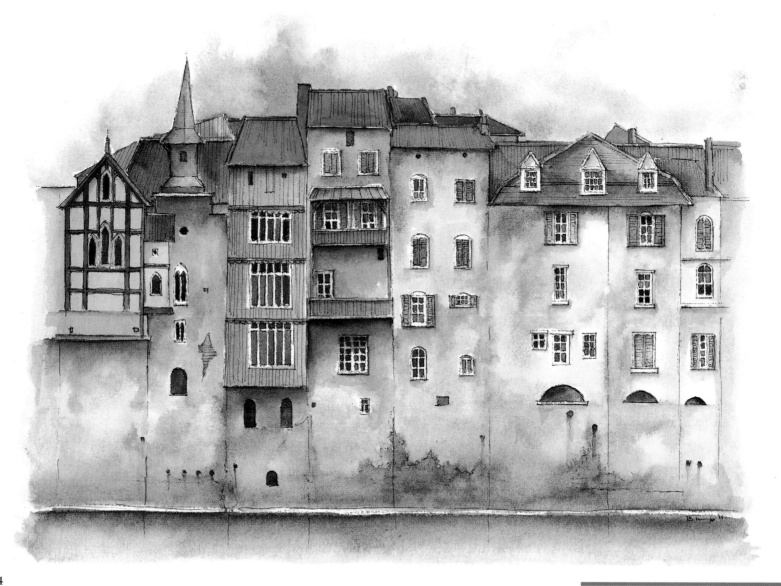

44

45

First, having completed the initial sketch and painted the sky, I established the basic tones of the walls and water. The walls were mixed with Yellow Ochre and a little Raw Sienna. This combination provided a tone that was suitable for the once-bright, but now faded, plaster that covered the walls. The water was achieved by using the same mixture, but with the addition of a little Olive Green and Prussian Blue. This watery wash was applied to all areas and left to dry.

46

FIGURE 46

The next stage involved mixing the stained mould colour to apply to the areas where the water and walls met. This was mixed from Olive Green, Burnt Umber, and a little Prussian Blue. The blue was added to give a 'cold' effect to this area, and to prevent it from looking as if a bush or some healthy shrubs were sprouting from the walls. The paper was then turned upside down, and a thick line of paint applied along the top of the waterline with a No. 4 brush. The whole mixture was then washed downwards (although it really is upwards on the building) with an extremely wet No. 12 brush. This was left to run into its own shapes, and blotted where appropriate, the paper being turned where necessary to encourage the paint to run into the water outlets.

As this dried, the paper was turned back to its correct position and the water given a similar treatment. The mixture previously

used for water was washed along the lower line of the very distinct water-mark, leaving a clear white(ish) strip exposed. This was then washed downwards with a wet No. 12 brush and left to run; no blotting was used on this occasion as the water was too grimy to be reflective.

Having painted the central feature of this composition, the rest of the buildings could be completed. This involved much localized painting and blotting, selecting the areas of crumbling, patchy, or faded plaster, applying a slightly darker tone to these sections, and either blotting the wet edges around them or allowing the paint to run and dry naturally.

One other familiar characteristic of waterfront buildings is the balconies and 'overhangs' that will often be found. These frequently served a very practical purpose, enabling the owners to haul items up from river craft, or to lower objects down onto them, increasing the speed of the turn-over trade. Obviously, these overhanging structures will cast substantial shadows directly underneath, and, depending on the direction of the light, probably to one side. These shadows were graduated and mixed in with the patchy shading on the walls without any distinctly-defined shapes, making them all the easier to paint.

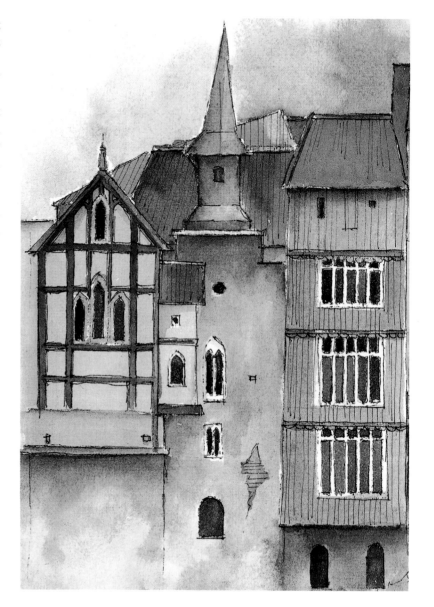

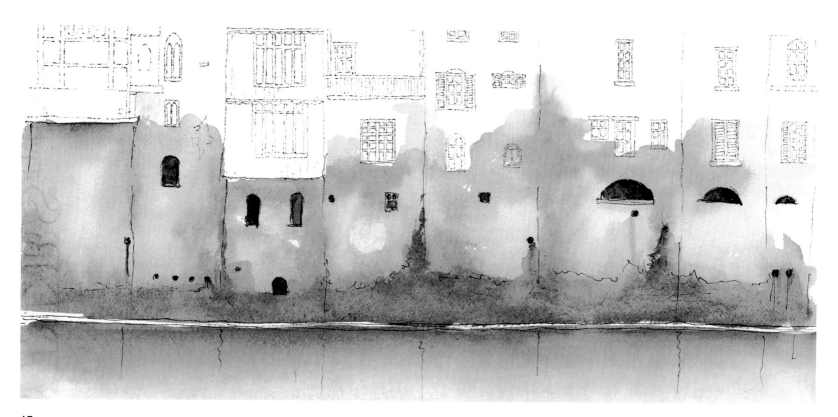

47

FIGURE 47

This picture did need more than the usual amount of post-painting drawing. The multitude of windows and shutters all required a few quick sketchy lines on their shaded edges; the timbers on the balconies needed emphasizing, and a few vertical lines were drawn onto the water to give the impression of a still, non-moving river.

FIGURE 48

This is a painting of one of the many palaces to be found on Venice's famous canals. This is, in fact, the Ca' D'Oro, which is considered by both Venetians and visitors to be one of the most beautiful of the palaces to be found on the Grand Canal. The façade is completely covered in marble. The highly-decorative inter-woven Gothic arches are highly typical of the fifteenth-century Venetian style. This was one of the most splendid patrician dwellings of its time.

The intricacies of the Renaissance architecture demanded much attention being given to the basic pen line drawing. On this occasion, because of the level of detail required, the 'sketch' did grow into a drawing out of necessity. The symmetry of the palace front made it easy to construct, once I had established the centre vertical columns and the horizontal balconies. It was then really a case of ensuring that the gap between each column was even on either side, resulting in the columns being evenly spaced. The balconies and the decorative mouldings along the roof all required particular attention in the earliest stages of this picture, most especially the plaster moulding, constructed into decorative rectangles, which surrounds the windows and visually breaks up the front into well-defined sections. These became very significant when it came to painting the walls, as they cast very slight (but very important) shadows.

As there was not a cloud in the sky on the day this picture was painted, no blotting was required. The pale wash of Prussian Blue was painted carefully in between the decorative parapet and allowed to dry of its own accord. The soft pastel shades of the Venetian buildings emitted a brilliant glow on the sort of day when even the wettest of paints will dry rapidly in the hot Mediterranean sun. These walls were painted quickly, and needed no toning or blotting, as the smoothness of the walls was attained easily with little paint in such atmospheric conditions.

In fact, it could be true to say that this picture stands by virtue of its shadows. The white stone pillars appear so strong because of the dark shading behind them. This was achieved by painting a strong mixture of Prussian Blue and Lamp Black at the top of the arches, and then washing it downwards with a watery brush (the same one as was used for applying the paint in the first instance, just dipped in the water container and rinsed slightly). The sections in between the balcony rails were also carefully painted with the same thinner mix, but with a No. 1 brush. The sections at the top, incidentally, were painted with the same size brush, but with the first dark paint mixture that was applied. This progression from dark toning at the top to lighter at the bottom provides a welcome visual relief from the starkness of dull, flat shadows.

As the sun was very strong, the shadows were very clear and needed little washing or blending. This is the point at which the significance of the decorative plaster moulding that I mentioned earlier is evident. It is of great importance in the initial sketching, as it casts a slight shadow to one side, thus giving some vital detail to otherwise plain blank walls. Once the paint used for the shadows was dry, the shaded sides of the moulding were picked out for redrawing in pen, just to emphasize the strength of the light on that particular day.

The water of Venice is, without doubt, dirty and polluted. But when the light is right, catching both the building and the water, the effect can still be very pleasing. Here the pale pastel shades of the palace façade, reflected in the water, created a near emerald green colour (mixed in with a little grime, of course). This colouring was mixed from Prussian Blue, Burnt Umber, a small amount of Olive Green, and much water. This was washed across the paper freely, and blotted vertically where the white pillars reflected. These reflections were then picked out with a few quick pen lines to complete this watery scene.

FIGURE 49

This illustration of Lerwick harbour in the Shetland Islands takes us away from inland waterways and out onto the open seas. The Shetland Islands are a haven for artists, with their rolling hills, simple stone crofts, and the many sheltered bays. The buildings are, however, grey: grey stone walls built on grey stone paths with blue-grey slate roofs. The high amount of rainfall that the Islands receive annually goes a long way to maintaining an overall grey look to the towns and bays.

In an area devoid of natural colour, the artist has to go in search of shapes instead. This set of buildings proved ideal—an unregimented set of irregularly-shaped buildings that climbed from the water's edge gently up into the town.

The shapes of the individual buildings were simple, but the composition complex, requiring perhaps a little more of my attention than the usual quick sketch before I started to paint. There were no real perspective problems, only the jigsaw (i.e. making sure that all the interlocking sections fitted together in the 'stepped' manner of their construction).

The colouring throughout this painting was simple: varying mixtures of Prussian Blue and Burnt Sienna, wetted and blotted to record the interplay of light in and out of this patchwork of stone buildings. The bottoms of the seaward walls will be subject to growths of damp mould, especially around the tide-mark, which was intentionally left white so as to create an important visual break between the sea water and the houses.

The major feature, and the largest area in this composition, naturally enough, is the sea. Unusually for a set of islands surrounded by complex currents and surging tides, the sea was particularly calm when I made this painting. Any large expanse of water will reflect the other unavoidably large expanse—the sky. The sea, therefore, needed a significant quantity of Prussian Blue in the mixture to complete the colour balance. (I would not generally consider using much blue in a sea mixture.) The mix is a combination of Prussian Blue and Burnt Umber in equal parts, which was washed onto a previously-wetted area of paper and allowed to run. The reflections from the buildings were quickly blotted vertically. The darker tones in the water were then painted vertically, with very wet paint being pulled downwards in between the blotted reflections. These areas were later picked out with a few emphatic pen lines.

The very last stage was to add the artificial colour of the row of buoys that spread across the bay. These were painted by applying a watery mix of Winsor Red, which naturally bled down the paper, forming its own reflections. When this was completely dry, a thicker Winsor Red mix was painted onto the buoys, without any bleed, resulting in their standing out considerably against their now faint and watery reflections. Again, the reflections were picked out with a few short, sharp pen lines to complete this calm waterfront painting.

CONCLUSION

Always look to the base of waterfront buildings, as this is where the dampness is most likely to have caused some significant disfiguration of the buildings' natural colouring. Tide-marks are always worth emphasizing, as they form a natural visual break between the buildings and the water. Finally, reflections in still water are best created by blotting vertically and following this up with a few corresponding pen lines to emphasize their shape.

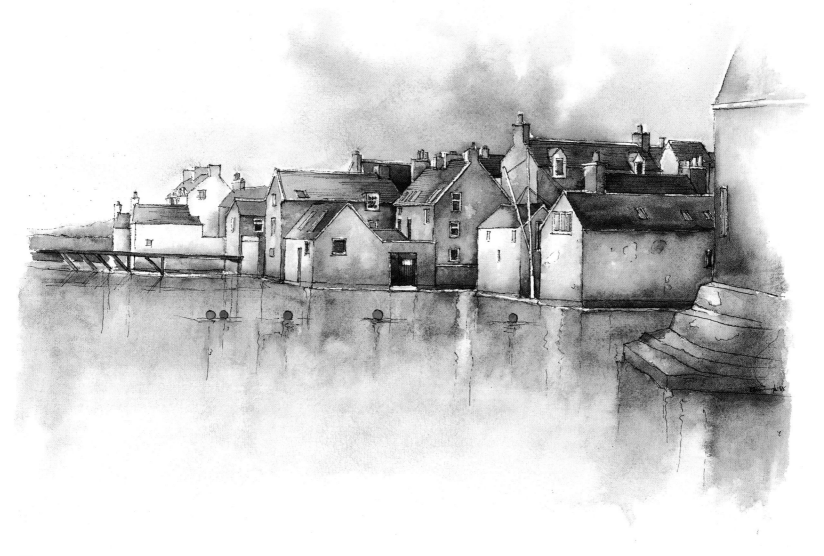

49

= 8 =

COMMERCIAL BUILDINGS

Probably the greatest appeal of commercial buildings (shops, pubs, bars, cafés, etc.) is their contrived attraction. They are there, after all, to attract you inside to buy something; so their fronts or façades will often be bright, occasionally garish, sometimes unusual in design, or overtly traditional in an attempt to evoke some nostalgic sentiment that will soften your resolve and make it easier for you to part with your money.

FIGURE 50

Painting the fronts of commercial buildings will often require some careful observation of lettering on signs—often the front will be of little interest without a particularly bold or bright shop sign or board. This is very much the case with this first illustration. This wooden boarded building in the tourist town of Winthrop, Washington, would be of little visual significance or attraction at all were it not for the interesting and attractive hand-painted sign that stands above it. This sign has a naïve appeal in its nostalgia and is doubtless all the more commercially successful for this.

Yellow Ochre

Burnt Umber

Prussian Blue

Olive Green

Raw Sienna

Winsor Red

Much attention was required in the initial sketching stage to ensure that the symmetry of the lettering on the sign was correct. This was achieved by starting in the geometric centre and working outwards, one letter at a time, first to the left, and then to the right. This work will probably have been done for you already by the sign-painter, who had to plan for the asymmetry of larger letters such as 'M' and 'W'; so just copy his efforts, working out from that centre point, and all should be well.

One other important consideration is that the sign is painted onto wood, and, as the paint has weathered, so the planks of wood begin to show more. For that reason I sketched a few lines across the sign to represent the planks and to add a little authenticity to the picture.

Having completed the sketch, it was particularly important to get a solid undercoat tone onto the paper, as much paint has to go on top of this. So I mixed a basic wash of Yellow Ochre and Burnt Sienna and applied it to dry paper with a No. 6 brush, changing to a No. 2 brush when it came to the area that required careful painting around the lettering on the sign.

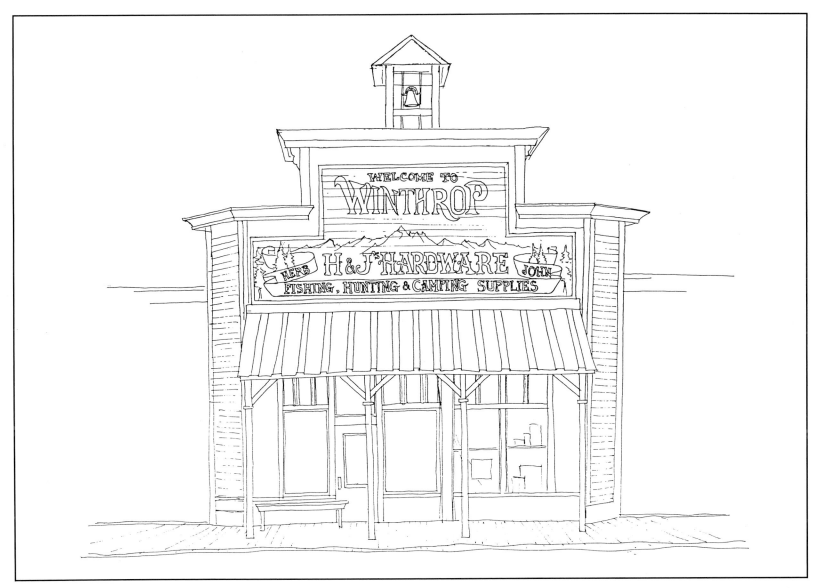

51

FIGURE 52

This set of illustrations shows the step-by-step method that I recommend for painting signs, boards, and any type of large display lettering. Here the basic undercoat was established around the areas that would have a strong wood tone and possibly have shadows applied at a later stage. The lettering, and the painted scenery, was treated on its own merit and required under-painting with its own tones, leaving the white areas totally white.

53

FIGURE 53

The next stage was to establish the basic tones of the painted sign. The graduated green was a mixture of Olive Green and Yellow Ochre; I painted this onto a Prussian Blue base, taking great care around the lettering. Had the lettering been of a darker colour, it would have been fully acceptable to have washed over it and painted the letters on top with the darker tone later (and this worked perfectly well with the lettering on the scroll underneath). But once you have established a tone, it is virtually impossible, with the translucent qualities of watercolour paints, to apply a lighter colour on top successfully: the dark will always show through.

54

FIGURE 54

Having completed all of the under-painting, the final stage of development could begin. The addition of further blue tones to the mountains, the toning on the scroll, and the flat, accurate painting of the lettering within the sketched guidelines, could get underway. The lettering was painted with slightly thicker paint than usual, as no runs or bleeds in any shape or form were required

here, and applied with a No. 1 brush, to re-create the sharpness and clarity achieved by the artist who painted the original.

The next stage in this painting's progress was to develop the shading and to paint the large-scale windows. To ensure that the windows reflected the colours of the immediate environment, a mixture of Lamp Black, Prussian Blue, and Burnt Umber (for the wood) was mixed. This was then washed onto dry paper and pulled downwards to achieve a graduated effect—the top of the window

being by far the darkest as it is directly behind the window shade. The few odd shapes of old tin cans and biscuit barrels that could be seen in the window were then gently blotted (so as not to remove the full window tone—only to lighten it a little) and then 'touched in' with a very watery and pale mixture of their particular colour, to give the impression of their being behind glass (too strong a colour and they would appear to be in front of it). The whole effect of a large-scale window was emphasized even more by applying a diagonal wash of the original window mix across the glass and blotting out a diagonal strip to act as a reflection.

The shadows from the awning and the over-hanging roof were strong and needed no blending or blotting. A confident application with a No. 4 brush soon gave this painting its full three-dimensional effect. As usual, certain sections on the shaded sides and the underneaths were picked out for emphasis with sharp pen lines.

Finally, it must be said that, however attractive these buildings in Winthrop are, they are only a façade, built to resemble a movie set and are, as was previously mentioned, little more than a tourist attraction—but a most pleasant and successful one at that!

FIGURE 55

A contrasting culture, but a similar commercial concept, linked the façade in Winthrop, Washington, and this particular shop front in Covent Garden, London. Both appeal successfully to our sentiments—one to the freedom of the pioneering spirit of the old Western days, the other to the nostalgia for Dickensian London, with the traditional bow-fronted window. I personally found the appeal of this picture in the visual contrast between the sombre tones of the 'Old Curiosity Shop' frontage, and the brightness of the hanging plants at the top, and the dried flowers in the baskets at the bottom. The wooden horse also made it a quite irresistible subject.

The sketch was made relatively simple by the geometric symmetry of the actual shop front. The lettering, however, did not coincide with this structure, and so I chose the 'L' above the door and worked to the left, and then the right, progressively.

This was a classical case of establishing an undercoat from the beginning and painting the many delicate, but nevertheless important, shadows onto this at a later stage. The sombre green colour used was a mixture of Olive Green and a little Burnt Umber, washed on carefully with a No. 2 brush around the hanging plants, leaving these shapes still as blank paper, but more freely with a No. 6 brush across the remaining woodwork.

Starting at the top and working downwards (to allow the paint to run in the right direction, and to prevent myself from resting my hand on an area of wet paint) the hanging plants were painted as the next stage with a basic mix of Yellow Ochre and Olive Green. Before they had time to dry fully, a few spots of Brilliant Yellow paint were applied to the top of the plant shapes, and allowed to bleed, mixing naturally with the remaining green. This not only provided more depth of tone within the plants, but also made them stand out against the dull green background (remember the push-pull effect described in Chapter 4).

The next stage was to get to work on the windows. As each separate pane of glass was set into the window frame individually, the chances of each one reflecting the light at a slightly different angle were greatly increased. For this reason, each pane was painted individually to record this effect. The many shapes and colours, distorted behind the curved glass, were painted on top of an initial pale grey undercoat, and then the darker window tones added and blotted in rapid succession to achieve the light reflections. Although some continuity of line, shape, and tone did exist between separate window panes, the odd break in this, or slight change of tone or shape, only served to enhance the overall effect.

The dried flowers in the foreground were painted in exactly the same way as the hanging flowers—the basic purple tones painted with a Prussian Blue and Winsor Red mix. Before this had time to dry, a much more condensed colour was applied to the top of the flowers and allowed to bleed naturally downwards.

The final stage was to look carefully underneath the eaves and overhangs, and to paint in the shadows using a No. 2 brush. The light was not as strong on that day so they did not require blending downwards.

The structure of this frontage, with so many carved decorations, made it ideal for drawing onto in pen, picking out the lines on the shaded sides, and leaving the other sides by way of subtle contrast.

55

FIGURE 56

The English public house is a hallowed institution, with replicas found today in Spain, Germany, Denmark, America, Canada, and Australia, and it has come a long way since its humble origins in medieval England. In fact, the English pub is something of a hybrid, having developed from both the ale-house (selling beer) and the inn (which offered accommodation, as well as the traditional refreshments). With the arrival of the beer tax in the early eighteenth century, many customers turned to gin, and, as this trend developed, so the drinkers found a home in the flamboyant and darkly-decorated 'gin palaces' of Victorian London.

This particular painting is of a typical pub which could be encountered on any street corner in any town or city in England. These corner pubs are good exercises in perspective, as they tend to be in the centre of many converging lines, with an assortment of windows to be fitted in between. As was mentioned in Chapter 5 on stone buildings, the corner often acts as a good starting point from which to establish the perspective lines. In this particular picture, I started with the top lines of the roof and the bottom lines of the walls, and made sure that all the lines in between converged correspondingly.

As this was a four-storey building and I was looking up at it, it was vital to include both the underside of the parapet, and the inside and top edges of the inset windows. The flat edge of the facing corner provided a good visual balance, with its 'flat-on' windows, lamp, and doors. A fair amount of attention was also given to the decorative wooden panels and edgings in the initial sketch stage, and this was to prove useful later on.

I washed on the main undercoat colours quickly here (avoiding the windows both top and bottom), the plaster walls being a Yellow Ochre and sky colour mix, and the wood panelling being a

56

straight but watery Burnt Umber. The next coat for the shaded side of the top walls was Yellow Ochre with more sky toning, washed and blotted appropriately.

The lower section, however, required more careful attention. There, I had to observe the insides of the window arches particularly carefully, making sure that the shadows painted with a No. 1 brush were all on the same sides. The wood panelling previously mentioned now comes to the forefront of this composition. Being of a lighter tone in the centre, it allowed an interplay of tones between the light panelling and the dark panelling, and the shadows that created the middle-range tones in between. The dark wood panelling colour was created by mixing Burnt Umber with a small amount of Prussian Blue, and the light wood panelling was a combination of Raw Sienna and Burnt Umber. The shadows were a watery mixture of the two.

Pub windows are generally dull, and often etched, resulting in few reflections; so a simple Prussian Blue and Lamp Black wash was applied and blotted partially for effect only.

FIGURE 57

This painting of a Parisian café is similar to the painting of the Rhine château (page 65) in that it was a very quick sketch, both in pen and paint, only this time it was to dodge the rain showers, not because of fading light. The great appeal to me of this scene was the contrast of the green shutters with the pink painted walls, counterbalanced tonally by the bright red table cloths and parasols outside on the pavement. The contrast of the small café nestling into the large white (albeit grimy) concrete buildings behind also formed a good contrast. Somehow it just all seemed right for a painting!

To increase the perspective and to include more of the attractive cobble-stoned road, I used the technique described in Figure 29 of taking the road from directly under my feet. In fact, the technique for painting cobble-stone paths is the same as that used for stone buildings, i.e. pick out a few stones initially in pen; wash and blot, and a few more stone shapes will be formed by the act of blotting.

The wetness of the concrete walls required much washing and blotting to achieve the patchy effect on both the café and its backdrop buildings. There were few shadows that day—just enough to distinguish one side of the building from the other, and to give an 'edge' to the table cloths and parasols, which were painted with Winsor Red and toned down a little with Prussian Blue, and blotted on the lightest side. Still, even on the dullest day, a subject for painting can always be found.

CONCLUSION

Lettering will require special attention in the initial sketch, and its symmetry is best achieved by starting in the centre and working outwards on each side alternately. 'Dickensian' windows are best treated as separate panes of glass, occasionally breaking the continuity of a line or reflection. Finally, look out for the variety of wood tones in public houses.

WORKING BUILDINGS

Buildings have, throughout history, and in every nation on earth, always been functional (with the tiny exception of those whimsical, purposeless constructions known as follies). Whilst the majority of buildings in any village, town or city will be for domestic use as residences, a certain proportion will have been built specifically for the purpose of work, be it commercial or not. In towns and cities these will be offices, shops and factories; in the countryside these will include oast houses, windmills and lighthouses, and it is these country buildings that are considered in this chapter. Today, only the lighthouses really serve their original function; the others are used for museums, as tourist attractions or education centres, and even individual dwellings when they fall into private ownership. Their current use will affect only their accessibility, since most are listed buildings with severe restrictions on what can and cannot be done to the building by way of additions and alterations, and so the outer fabric is very much as it has always been, changed only by the effects of the centuries of wind, rain, sun, snow and ice. They are also very attractive to paint, and are worth seeking out for an expedition.

The hop fields of Kent are still dotted with their unique pieces of architectural heritage—the oast houses. These are quite fascinating structures, and served a most useful purpose in drying the hops for making beer. Inside the oast houses, the hops (traditionally picked by East End Londoners on a working holiday) were spread on a drying floor across the chimney, and hot air was blown up through them from a heat source (traditionally an open fire) on the ground floor below. The cap, or 'cowl' as it was known, was a cunning device which turned with the wind, operating a trap door lower down on a pivot, which controlled the ventilation. Once the hops had dried, they were cooled in the barn-type buildings attached, and pressed into canvas bags ready for the brewer to collect.

FIGURE 58

This particular painting is, rather like Figure 27, very much a case of the surrounding environment being just as important as the actual buildings themselves. Starting off with the buildings as the central theme of the composition, however, a couple of points are worth noting about drawing/sketching oast houses. The first is that the actual conical brick towers themselves are symmetrical, despite the optical illusion of over-balance created by the white wooden cowls on top, which are directional and lean to one side. The other point to consider is that, as you will generally be looking up at these cones, the curve on the top of the stack will be greater than that at the bottom, with the lines of bricks curving correspondingly between these two curves.

The day on which this picture was painted was one of those days when a late autumn breeze gently skimmed the tops of the fields, and the sky held an intensity of colour and scale that was striking. The tall brick cones of the oast houses positively glowed that day, set against the sky, so some serious painting was required to record this scene.

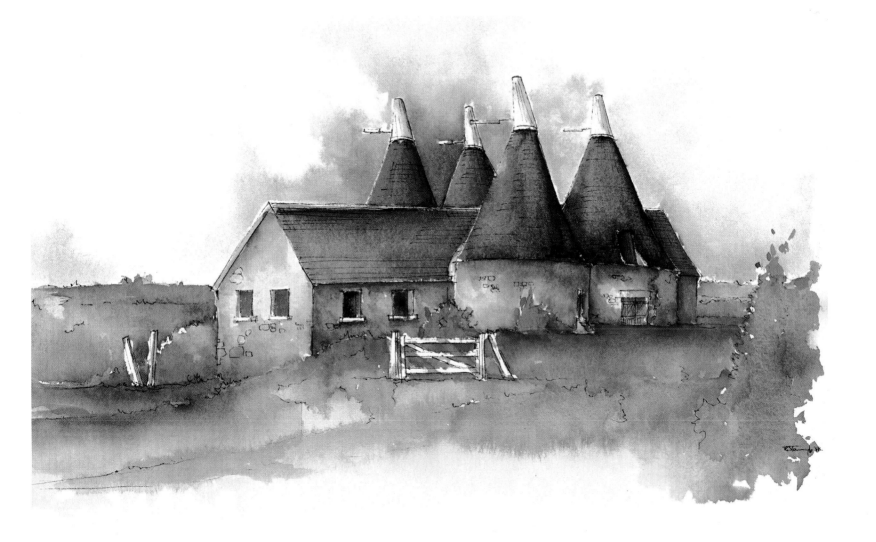

58

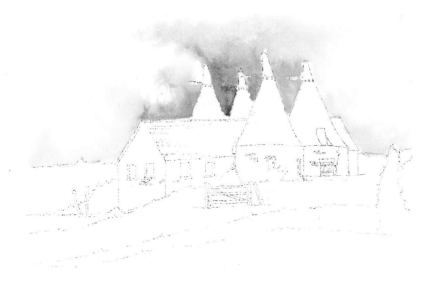

59

FIGURE 59

A heavy mixture of Prussian Blue and Burnt Umber was applied to a very wet sky area while the paper was held upside down. This allowed me to paint with great care in between the funnels, allowing the paint to run its natural path across the wet, blank paper; I then blotted this to create the cloud shapes that hovered oppressively above the horizon. With this quickly dried by the autumn breeze the basic undercoat could be applied.

FIGURE 60

This comprised a watery Raw Sienna for the bricks of the funnels; Raw Sienna and a little Yellow Ochre for the base brick work, and, very importantly, a basic ground colour that was Olive Green only at this stage, but with a strong bias towards Yellow Ochre.

The next stage is the key to success when painting oast houses, but the technique to be described here is applicable to any curved or round building and will be used with windmills and lighthouses.

60

FIGURE 61

61

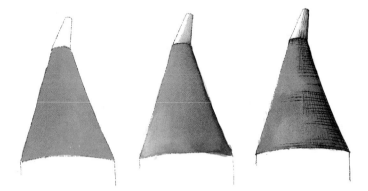

To create the circular effect required, the basic brick toning has to be applied to a dry surface so that it dries flat and evenly, with no runs or bleeds. When this is dry, the same colour should be mixed again, but with an increase in the darker constituent paint to darken the tone.

In this example I used a mixture of Raw Sienna and Burnt Umber, increasing the amount of Burnt Umber (the darker) and the subsequent tone for the second application. I then painted this onto the shaded side of the tower in a line, using a wet No. 6 brush. I then rinsed this brush quickly in clean water and used it to pull the paint downwards, across the tower shape. This action resulted in a residue of dark paint on the shaded edge, with the rest of the paint drying in one graduated tone. Sometimes, on very bright days, it may be appropriate to blot the non-shaded side in order to add an even greater degree of contrast to the particular building.

The white boarded cowls, of course, cannot be ignored and may be painted in exactly the same way, but using Prussian Blue with a little brick mixture colour added to tone it down slightly. (This is exactly the colour and the technique that I use for painting white lighthouses, only much more blotting on the non-shaded edge is generally required to maintain the brilliance of the white.) To complete the graduated effect on the oast house chimneys, I sketched a series of radiating vertical lines onto the darker side from top to bottom, and a set of curved lines across the towers, completing the optical illusion of the curve.

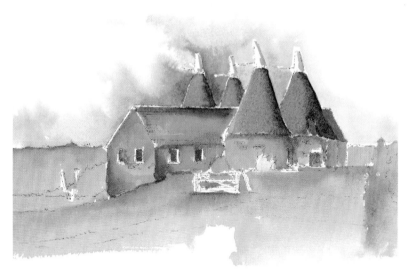

FIGURE 62

Having completed the central part of the composition, I could now give my attention to the remaining areas. The stone colouring on the base and the barn were achieved by wetting and blotting with a Yellow Ochre, Burnt Umber, and Prussian Blue mix, with the particular addition of some Raw Sienna to the roof by way of a reflection.

FIGURE 63

But one of the main attractions of this scene from the very beginning, apart from the oast houses themselves, was the glow of the warm autumnal ground colours. These were achieved by the introduction of some very wet washes of Winsor Red and Yellow Ochre into the ground areas, which were allowed to run naturally. Occasionally some plain water may be added directly on top if the colours do not run immediately, or do not go straight to where you want them. This is a skill that is much fun to practise, and takes only a short time to develop fully.

I completed the painting by picking out a few lines on the side of the gate and the wooden posts, to highlight the white wood against the dark ground.

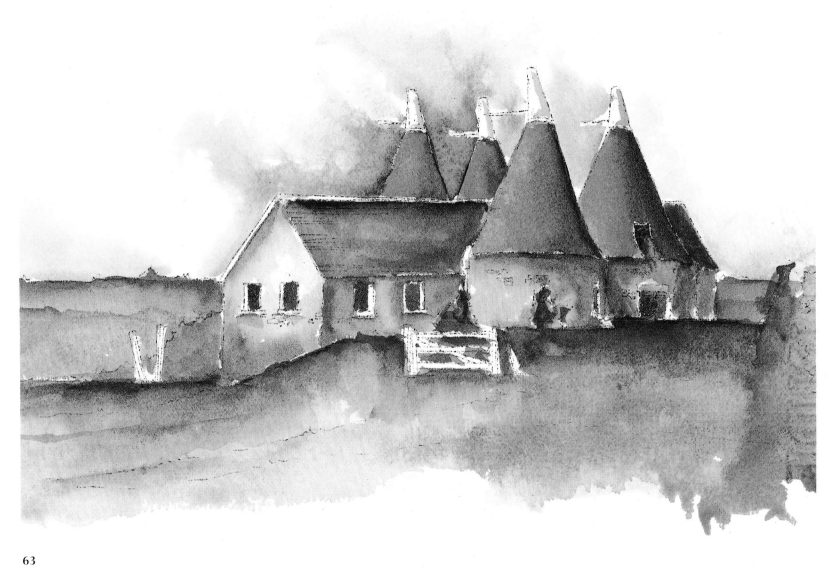

63

This next illustration moves across Britain to the Suffolk coastline and the magnificent sight of a gleaming white wood cap of a brick windmill breaking the flat skyline. Windmills, in general, have an interesting history. Millers were once proud of their wealth, and their standing in the community that this allowed them, and this civic pride was reflected in the splendour of the windmills that they built. Unfortunately for these affluent millers, the introduction of steam-driven mills brought about a sharp decline in the millers' trade, and the introduction of electricity finally brought about the inevitable demise of most working windmills. The thousands of windmills that dotted the British countryside before the end of the nineteenth century were consequently left to fall into ruin, leaving few still in full working condition. Fortunately for our generation (and those to follow), a handful of enthusiasts embarked on a vigorous conservation programme and have maintained various mills, such as this one at Cley on the north Norfolk coast.

Other countries, such as Holland, have fared better, and the windmill is there a familiar, indeed characteristic, feature of the landscape; Greece too has many windmills, though these are of a very different design.

Whilst there are, worldwide, many different types of mill, this particular type shown is called a 'tower mill'. One of this mill's major visual attractions is its height, which had the fairly obvious purpose of raising the cap and the sails higher into the air, and thus into stronger winds.

This was another picture which required a close examination of the curves of the structures, since, with it being so tall, I was looking up at nearly everything, and seeing the underneath of balconies, extensions, and parapets. This is an important point to remember when drawing or sketching these towering structures—the undersides are important. The angles of the

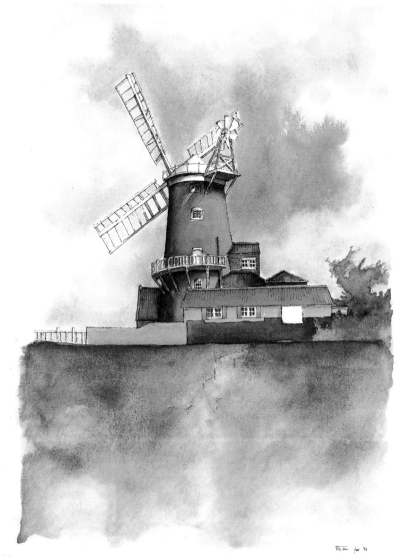

64

windmill sails also required considerable observation in the initial sketch; they are, in fact, twisted, rather like the blades of an aeroplane propeller. Finally, on the initial sketch, I chose to leave a large area of foreground in the composition rather than moving closer to the mill. This increased the sense of perspective and distance, giving an even greater impression of height and grace to the mill.

With so much sky to be painted, and the windmill blades to be left white, a certain amount of care was required here. Because of the scale of the sky, it had to be wetted to allow the painting and blotting to take place, but the white sails had to be kept white. This was achieved by soaking the sky thoroughly before any paint was applied, then blotting the water from the sail areas, leaving these sections dry and acting as a 'halt' for any stray runs when the sky was actually painted. So the sky was painted with a No. 8 brush, still carefully, but not with any undue concerns about the paint bleeding into the white areas of the sails. When the sky had dried, the areas of sky showing through the sails were carefully painted with a No. 1 brush onto dry paper, avoiding any runs.

Many similarities exist between this type of windmill and the Kentish oast houses. The prominent Raw Sienna colouring, and the technique of painting to create the graduated shading and subsequent curved effect, are common to both. However, this painting was a little more complex than that of the oast houses, due mainly to the specific shadows cast by the outstanding features. These shadows followed the natural curve of the tower, and curved diagonally downwards at an angle that simply had to be looked at, judged, and painted with confidence. The previously-mentioned undersides also required shadows, as did the white sails and the supports of the balcony.

The foreground had to suggest the wetness of the Norfolk coastline, and it was wetness that achieved the result. The foreground was soaked with clean water and, whilst still very wet,

received a wash of Olive Green and Yellow Ochre. Before this undercoat had time to dry, more applications of this mix, in varying strengths, were applied and left to take their natural course vertically down the paper. The light path was blotted through the centre, but that was my only interference.

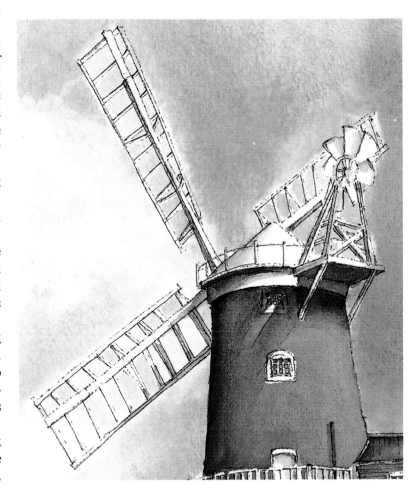

FIGURE 65

This last illustration is perhaps the most extreme of angles included in this book. Not only is the subject a tall tower, but the view was from well below ground level, being painted from a lower rock.

This lighthouse in Michigan, USA, is a fine example of some of the more unusual types of buildings to be encountered. Without the light-tower, the house could have been in almost any North American suburb, but the addition of the light-tower changes not only its character, but also our perception of it. It is, in fact, a lighthouse with living quarters attached, and not a residential element of suburbia any longer. The inclusion of so much foreground, as with Cley windmill, enhanced the overall effect of height, lowering the skyline, and assisting this building to look as grand in paint as it is in reality.

CONCLUSION

Always consider the underneaths of structures that are part of tall towers, and include these in your initial sketch. Graduated toning is important to round buildings, and can easily be achieved by creating the contrast between the light and shaded area, whilst washing the section in between.

65

CONCLUSION

Now that you have completed your paintings, the next consideration is what to do with them. Obviously some you will like more than others (although those that you reject may well appeal to someone else) and you will doubtless wish to frame some of these pictures.

Personally, I have always believed that you will never make a poor picture look reasonable by framing it, but that you can make an average picture look particularly good, and a good picture highly impressive, by the addition of a good mount and frame. I also believe very firmly that watercolour paintings need to be set behind a card mount within the frame; many different types of card are available in art shops and at picture framers. But my advice is always to take your paintings to a professional framer at first, until you get the feel for mounts and framing, and gain the experience to know not only what will look best, but also how to do it properly! Here, then, are some of the options that I recommend.

MOUNTS

Never use plain white (or black) card for watercolour paintings, as the glare of the white will distract the viewer from the painting. I generally use a cream card, or one of the many pastel shade cards that are commercially available; they have the effect of softening the surrounding edge of the picture, and creating a more pleasant effect overall.

It is always a good idea to select a mount that echoes one of the major tones in the particular painting, but if this proves to be too difficult in the case of, for example, several tones of green dominating the composition, then why not consider a double mount? This is where one card is placed behind another, leaving the edge of the bottom card showing, giving a double-toned edge to the painting. You can experiment here, alternating with a dark top card and a lighter inner, or a light top card and a dark inner. Simply try all the alternatives until you find the combination that best suits your painting.

The final possibility for mounting your painting is the most traditional form of watercolour presentation, and this is known as 'line washing'. This involves drawing, generally with a pencil, two or three borders around the window in the mounting card. These are then very skilfully painted with watercolour washes, chosen to reflect the tones and colours in the painting. Again, this is a technique that you may wish to experiment with, but you would be well advised to find a picture framer who can do this for you on at least the first occasion.

FRAMES

Again, a wealth of frames are available to you, from brightly-coloured plastic to traditional wood or gilt. I personally always like the look of stained wood with watercolours, and frequently choose

frames with a fine gold inner edge. No hard and fast rules can really be offered here—just rely on your own judgement, and, if in doubt, ask the framer's advice.

For those who want to attempt their own mounting and framing, many aids exist. Mount cutters that will cut accurately with a 45 degree bevelled edge are not too expensive, and mitre blocks are easily found today, although the amount of ready-made frames to be found in art and craft shops today really alleviates the need for such devices.

The other choice that you may well be offered is between non-reflective (or diffused) glass and ordinary glass. In my experience, ordinary glass, whilst sometimes irritatingly reflective (although not if hung in the correct place) is preferable, as the non-reflective type often has the effect of dulling the overall colours by diffusing the entire picture.

ART CLUBS AND CLASSES

How to progress with your painting is something that only you can decide, depending entirely upon your own motivation and the level that you wish to reach. If you do feel that you wish to become more involved with a group of like-minded painters/artists, then I strongly recommend joining (or even forming, if one is not already in existence) your local art club, group, or society (public libraries should be able to provide you with the name and address of the secretary). These organizations operate all sorts of activities, including day trips to popular sights, visiting speakers/demonstrators to meetings, and often exhibitions of members' work, and will definitely be made up of members just like yourself who are looking for both inspiration and companionship.

Several monthly magazines are currently on the market, and they contain all types of instructional and informative articles, as well as having diary sections where clubs can advertise, and many other valuable areas of current information. Then there is the Federation of British Artists at the Mall Galleries, 17 Carlton House Terrace, London SW1. This organization encompasses many professional societies made up of amateurs who have acquired membership by submitting their work to the open exhibitions.

Similar organizations in the US are: American Federation of Artists, 41 East 6th St, New York; American Watercolour Society, 47 Fifth Avenue, New York 10003; National Watercolour Society, 5441 Alcove Avenue, North Hollywood, California 91607, and American Artists' Magazine, 1515 Broadway, New York 10036.

Probably the most valuable source of help, however, will be the wealth of instructional classes that are available to people of any age throughout the country. Evening classes, which will be largely non-specialist, offering a general 'taster' or intermediate course, are unlikely to be able to help with such a specialized area as painting buildings or architecture. These are invaluable for the absolute beginner, but artists with a basic knowledge of painting practices, looking for someone to take them through to a stage of specialization, should look to the one-day or weekend courses. I strongly recommend the courses that specialize in sketching, drawing, and painting in built environments. I have taught on, and organized, several of these specialist courses myself, and am aware of many other courses run at local education authority and independent adult education institutes. Many of these courses will allow you the scope to work in your own media and on your own subjects, picking the tutor's brain and skills only when you feel they are required.

Finally, the most important aspect of learning to draw and paint buildings is simply going out and doing it. Yes, you can learn much from a book, but it is only when this is put into practice that you will begin to see results; and if you feel inclined to join a class and go out sketching and painting with other people, then the enjoyment and speed of learning doubles. However you approach drawing and painting buildings, enjoy it always!

GLOSSARY

ashlar Hewn blocks of masonry wrought to even faces, square-edged, and laid in horizontal courses with vertical joints.

background The area immediately behind the main subject of a composition, extending to the horizon.

bleed The natural action of one wet colour blending into another.

blotting The removal of surface water/paint with an absorbent material.

brick nogging The method of in-filling used to fill the spaces between timbers in timber-framed buildings. This is frequently, although not exclusively, found in a herringbone pattern.

coursing A continuous layer of bricks in a wall.

dormer A type of window placed vertically in a sloping roof, and having a roof of its own. This was usually a sleeping area, hence its name.

eaves The lower part of a roof projecting beyond the face of the wall.

flatten To detract from the three-dimensional appearance of any given area.

foreground The area immediately in front of your painting/sketching position.

gable The triangular upper section of a wall at the end of a pitched roof.

Georgian Classical style of building, chiefly small and domestic.

Gothic Name given to the 'pointed' style of medieval architecture, most prevalent between the thirteenth and fifteenth centuries.

herringbone Stone or brickwork set in diagonal lines, with alternate courses being laid in opposite directions, creating a zig-zag pattern across the wall.

Indian ink A black indelible ink which contains permanent properties.

jettying Generally found in timber-framed buildings. This involves the projection of an upper storey beyond the storey below, by means of beams and joists. Buildings can be jettied on more than one side and on more than one level.

keystones The wedge-shaped crown of an arch, or the centre stone on which pressure is exerted.

parapet A low wall placed to protect any spot where there is a sudden drop; frequently found on the edge of a flat roof.

pinnacle A small turret-like termination, crowning spires, buttresses, etc.; usually of pyramidal or conical shape.

porch The covered entrance to a building.

Renaissance A term meaning 're-birth', but referring to the late fifteenth-century return to Ancient Roman standards and influences.

residue An accumulation of pigment on paper after a paint wash has dried.

rubble Rough building stone or flints, not laid in regular courses.

sable Squirrel hair used for brushes.

sash window A window with sliding glazed frames running in vertical grooves.

stucco A form of smooth plaster-work.

terrace A row of attached houses built as one unit.

thatch A roof-covering made of straw and reeds.

tracery The ornamental intersecting stonework in the upper part of a window, used decoratively.

translucent The semi-transparent quality of watercolour paint.

wash The action of applying a very wet brush across the paper with either plain water or paint.

wattle and daub A method of wall construction consisting of thin branches, roughly plastered over with mud and clay. This system of in-filling was frequently used to fill between the timbers of timber-framed buildings.

weather-boarding Overlapping horizontal boards or planks of wood covering timber-framed walls.

wetting Applying a wash of plain water to blank paper.

INDEX